700028155304

D0611099

watercolour
for starters

Paul Talbot-Greaves

D&C
David and Charles

To my wife Sarah for her unending support
and assistance with everything I do.

A DAVID & CHARLES BOOK
David & Charles is a subsidiary of F+W (UK) Ltd.,
an F+W Publications Inc. company

First published in the UK in 2005

Distributed in North America
by F+W Publications, Inc.
4700 East Galbraith Road
Cincinnati, OH 45236
1-800-289-0963

A catalogue record for this book is available from the British Library.

ISBN 0 7153 2183 8 hardback
ISBN 0 7153 2185 4 paperback

Printed in China by SNP Leefung
for David & Charles
Brunel House Newton Abbot Devon

Commissioning Editor Mic Cady
Desk Editor Lewis Birchon
Art Editor Lisa Wyman
Project Editor Ian Kearey
Production Controller Kelly Smith

Visit our website at www.davidandcharles.co.uk

David & Charles books are available from all good bookshops; alternatively
you can contact our Orderline on (0)1626 334555 or write to us at
FREEPOST EX2 110, David & Charles Direct, Newton Abbot, TQ12 4ZZ
(no stamp required UK mainland).

contents

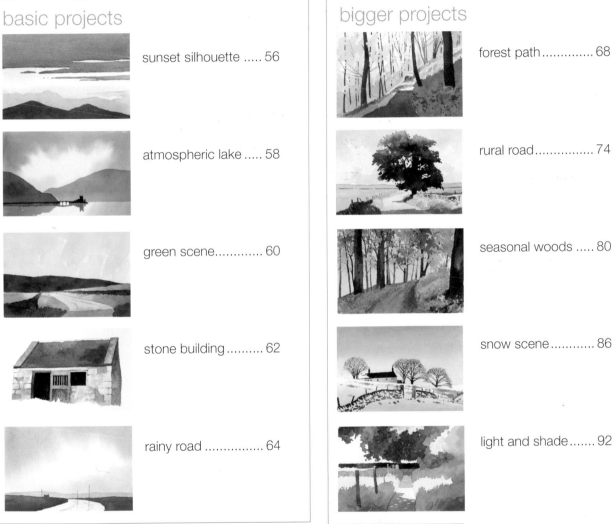

basic projects

bigger projects

introduction

Painting in watercolour is a challenge in itself, but at its best it surpasses all other mediums. The crisp, translucent finish to a watercolour has to be achieved with timing, precision and accuracy – skills that need time, patience and perseverance to achieve. Whatever level you take your painting to, you are assured of a very pleasant and often addictive journey.

The reason I took up painting was simple: I would often visit galleries or flick through books and magazines and enjoy looking at other artists' work, and I would then become inspired to paint for myself. But the transition from those early days of inspiration to turning out a watercolour that satisfied my own personal standards took such a long time that I came close to surrendering altogether. On a number of occasions I packed the paints away and they didn't come out again for quite a while, but time and time again I was lured into having another go, and I gradually found myself painting for progressively longer spells. The main reason why I continued throughout the ups and downs of learning watercolour painting was the very challenge of the medium – one day you win, the next you fail – and it is this fragmented progression that can entice you out of your everyday lifestyle and on to an emotional roller-coaster ride that you cannot get off. Welcome to the world of watercolour painting!

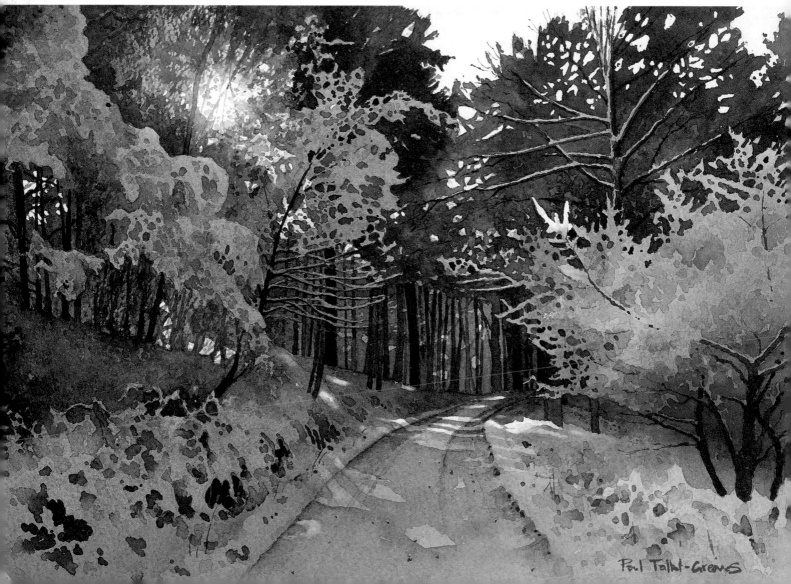

A Winter Afternoon, 22.9 x 33cm (9 x 13in)

Paul Talbot-Greaves

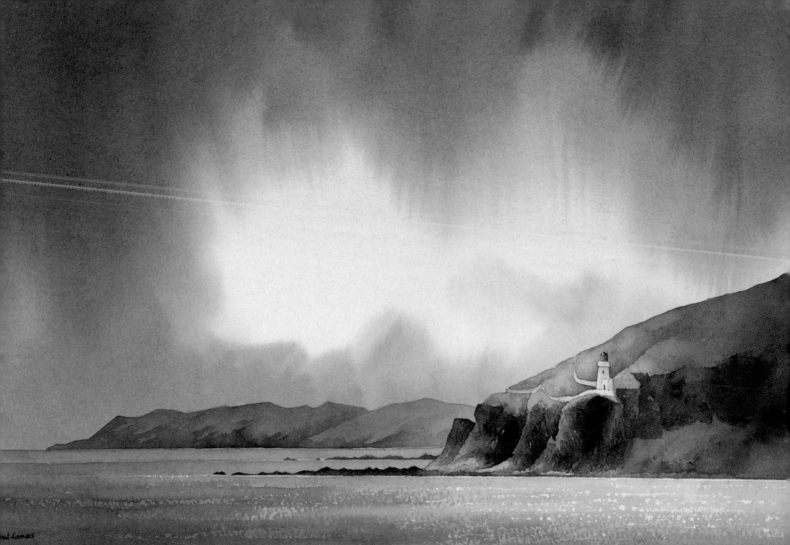

McArthur's Head Lighthouse, 33 x 50.8cm (13 x 20in)

beginning and progressing

For many people, insecurity about their work often becomes a creative barrier. One of the most frequent questions I am asked nowadays is not 'How did you do that?' but 'How long have you been painting?'. I know why the person has asked that question, because I used to say the self-same thing to other artists: it is a matter of comparison brought out by insecurity. Basically, if the answer to 'How long have you been painting?' is 'Twenty years' and you have only been painting for five years, this somehow sheds a glimmer of hope on your own abilities: you feel relieved that you still have time to reach the same standard. However, it really doesn't matter how long anyone has been painting, because we all progress at different rates anyway.

The shock that many of us experience is when we start to paint for the very first time – what we think we can do and what we can actually do are often two very different standards, especially during our early days of painting. It doesn't matter if you are eight or eighty-eight, you still have to begin from the same point, regardless of age; in other words, just because we grow older, this doesn't mean to say that our inherent abilities as artists grow with us. Painting is a skill that requires training and practice just as much as any other skill: you wouldn't expect to sit at a piano for the very first time and play your way merrily through a piece of Chopin, would you? Likewise, try not to expect to paint masterpieces without first learning your craft. Always try to bear this in mind when things start to go wrong with your work – as they will.

using this book

This book is aimed to guide you through the processes of handling watercolour, from your first attempts to building up more complex work, and it is filled with examples, ideas and exercises for you to follow. The first part gently introduces you to the medium and its materials, simple exercises get you painting as soon as possible, before small studies lead on to the projects at the end of the book.

However, you shouldn't necessarily feel that you have to follow this book like a recipe – and indeed, you will find some of the paintings harder to follow than others. Look upon it as being more like a map. If at any stage you wish to put it down and do your own painting, then do it – you will make plenty of mistakes at first, but then again, how else are you going to learn? Wander off by all means, but do come back from time to time and follow the general route that I have plotted for you. Enjoy your painting, take your time and, above all, keep practising.

understanding watercolour

The important thing about watercolour is that it is a transparent medium. The pigment is ground so fine that it settles in thin, transparent layers, and painting with it is like overlaying coloured sheets of glass.

The concept is simple, but it does affect the way we work with watercolour – compare it to using oil paint, which is a thick, opaque medium. With oils you can paint colours over each other, rather like overlaying coloured sheets of card, so you can place a yellow over a blue and it will stay yellow because of its opacity. Now try doing that with thinned water-colour: the transparent quality of watercolour means that the blue shows through the yellow, creating a new colour – green. Watercolour really is trans-parent, and this means that because colours show through each other, you cannot paint a light tone on top of a dark one; thin, light paint will not show up when painted on top of thick, dark paint.

creating light

To create any light parts or white bits, you need to retain the white of the paper right from the outset of the painting. The good news is that to whiten or lighten a colour you just need to add water, which is much cheaper than mixing colours with white paint. The more water you add, the lighter your colour becomes. To make a darker colour, simply use less water but more paint. To retain your white, you can either paint around an area or mask it out with masking fluid first. Masking fluid is a rubbery solution that you paint on to the paper; it dries quickly, allowing you to get on with the painting, and when you have finished you simply rub it off.

working from light to dark

In watercolour, you start painting with the lightest parts (which are usually the white of the paper, but could also be a thin colour) and work towards the darkest parts. This means you are technically working backwards: imagine you have a paintbrush in your hand and a palette full of paint, and you are about to paint a dark sky with a light-toned farm building lit up against it. How do you tackle it? Your brain will tell you to paint in the dark sky first, then the light building on top of it afterwards – but, as you have already learned, in watercolour you can't paint a light tone on top of a dark tone. So you have to stop and think for a moment: reserve the building

A Walk Through the Woods, 33 x 50.8cm (13 x 20in)
This painting utilizes the full range of watercolour techniques – from masking through to layering washes – all the time working from light to dark.

as white paper and then paint in the dark sky, working around it. This is known as working from light to dark, and you need to develop this skill until you begin to see different tones in everyday life.

The good news is that you don't need to be painting to practise reading tones; in fact, you can start right now. From where you are sitting, look for an area that is fairly dark, then look for any lighter parts that may be visible within it. Now look for the darkest area and then the lightest area. Screw your eyes up if this helps to concentrate the tones. Keep looking and try to imagine painting the scene, building it up in layers of watercolour working from the lightest tone to the darkest. It isn't that easy, is it?

layers and washes

In a watercolour painting the paint is built up in layers, and each application of paint to paper is known as a wash. Each wash or layer of paint is usually allowed to dry before the next one is added, and this process of building up washes helps you gradually develop tones, colours, textures and details. This may sound pretty straightforward, but each layer of dry paint can be easily disturbed with a brush and water, even when the intention is to add washes on top.

Watercolour paint is in no way fixed after it has dried, so if you are a little overzealous with your brushwork you may lift some of the original wash, and this will mix with the wash you are applying at the time – and too much overworking of this kind can result in nothing short of a mess. If this happens to you, don't worry; your technique will tidy up as you gain experience. The lesson here is that layers of watercolour need to be put down both quickly and accurately with soft brushes in order to avoid disturbing the underpainting.

Before we go any further, let's just recap on some of the important points:

- Watercolour is transparent and is laid down in thin sheets, similar to coloured glass.

- You cannot paint a light tone on top of a dark tone.

- Work from the lightest of the lights towards the darkest of the darks, and remember to reserve any white or very light areas from the start, either mentally or using masking fluid.

- Try to pre-plan your painting, taking time to look for the light-to-dark progression through the tones.

- Apply your washes with controlled speed. Don't be tempted to work back into them or to overdo the brushwork.

Q&A

'If I'm painting in layers, why do I have white paint in my paint set?'
This is a very good point. White paint, usually called Chinese white, opaque white or white gouache, is opaque and can be used at the end of a painting in its neat form to add the odd highlight on top of a dark layer or to reinstate an area of white paper that you have mistakenly painted over. Treat white paint with caution and try not to use it if you can, as it is far better to retain the white of the paper from the outset. Certainly don't mix it with other colours to make them lighter – the results are invariably messy.

materials

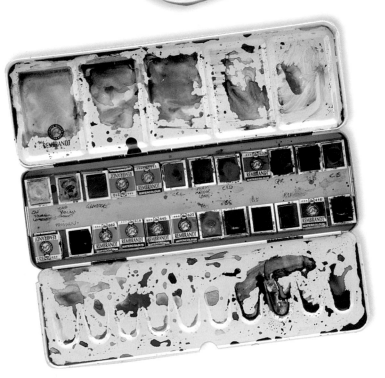

Now that you are aware of the properties of watercolour, it's time to take a brief look at some of the materials. You may already have a fair amount of the equipment shown here, and although you may want to skip this bit and get on with the painting, you should take an interest in the materials you use.

paint

Watercolour paint comes in two different forms: pans (small, solid cakes of colour) and tubes (small metal tubes filled with soft squeezable paint). The same paint is produced in either form – it is just the binding substance that differs – so although you may appear to get more colour in a tube than its equivalent in pan form, you don't really.

The choice of which to use is down to personal preference: I use tubes so that I have instant soft paint ready to go. Sometimes pans can take a little effort to work up the paint, and this can lead to the premature destruction of your brushes due to stirring the paint constantly, so if you prefer to use pans, keep an old or cheap brush for activating the paint.

student or artist?

A number of manufacturers make two different grades of paint, usually termed as students' and artists' quality – better terms would be practice and perfect quality. Students' paints are cheaper to buy than artists' paints and are usually bulked out with gum and fillers to make the paint go further. They're still good paints, however, and you should start with them, as hopefully you will be working your way through lots of paint.

Artists' paints are pure pigments that have been ground very fine and mixed with gum. These paints tend to be very strong and are capable of creating lots of colour, probably far more than you would imagine when you see the size of the tube or pan.

When you switch from using students' paints to using artists' paints you will notice the difference in the flow and intensity of the colours, but don't let this bother you at this stage – use the students' ranges for now and enjoy them.

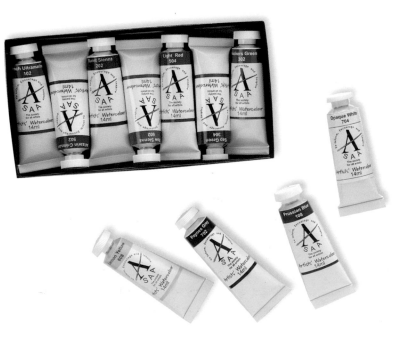

paper

Although this sounds pretty obvious, you should ideally use watercolour paper for painting on, as you will not be able to achieve your best work on cartridge paper, cardboard, cheap paper or even envelopes. Watercolour paper is made especially for use with the watercolour medium and is treated with size, both to waterproof it and to maximize paint handling. As you progress with your paintings, you will discover that all the different makes behave in different ways and are also capable of producing different effects.

Most watercolour papers are made from cotton rag or wood pulp and are available in a range of sizes and in single sheets, pads, blocks and even rolls. They are also available in varying weights and usually come with one of three different surface textures (but not always). Weights of paper vary between 190gsm (90lb) to 640gsm (300lb). I use various makes of paper, usually 300gsm (140lb), and depending on the effect I require, I use one of the three available textures: rough, NOT and hot-pressed (see right).

Because each brand of these surfaces and weights has its own characteristics, it is worth experimenting with them and finding which work best for you. As you progress you will become accustomed to the main brand names and manufacturers of watercolour papers, and, as with brushes, the price and quality of paper varies. As a guide, it would be fair to say that the quality of a paper will most probably be reflected in its price.

paper surfaces

rough

Rough paper can be used to achieve coarse watercolour effects and lends itself to highly textured work, such as drybrush effects. It has a heavily toothed surface texture, which varies between weights of paper and different manufacturers. When masking mediums are used on rough paper, they can give unpredictable results, due to the heavy undulations in the paper surface.

NOT or cold-pressed (CP)

Short for 'not hot-pressed', NOT is probably the most commonly used paper. It takes watercolour very well, has a medium-surface texture, and you can quite easily achieve drybrush effects on it as well as fine detail work. The name is a bit confusing, but just means that the paper has been cold-pressed and not hot-pressed during manufacture. If only many things in life were as simple.

hot-pressed (HP)

This paper is rather like cartridge paper to look at and is smooth to the touch. It is very difficult to achieve any drybrush or textured effects on this paper, but it is excellent for highly detailed watercolours. I use it for illustration work, where attention to accurate detail is required more than spontaneous, ragged brushstrokes.

stretching paper

Unless you are using 640gsm (300lb) paper, which is thick enough to hold itself flat, before painting you have to stretch your paper to prevent it from cockling or ruckling up when you apply big washes of paint. This takes time, but a well-stretched piece of paper gives a beautiful flat surface on which to work.

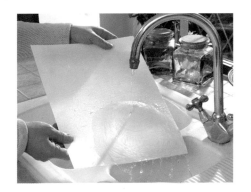

You need a piece of solid board around 12mm (½in) thick, a roll of 50mm (2in) brown (wet and stick) gummed tape and the paper. First, cut your paper to size and then cut four strips of gummed tape, one for each side. (Masking tape does not work because you need to ensure that the tape will

adhere to wet paper.) To wet the paper just run it under a cold tap, wetting both sides for a few seconds until it is evenly saturated. Now, hold it up by one corner until all the residue has run off, then place it onto a level board and let it settle until all the surface water has been absorbed. This will take a few minutes, after which the paper will have lost its sheen and may appear to be almost dry on the surface.

Now wet the gummed strip with a damp sponge or cloth – do not use too much water, as this could saturate the glue and the strip may not hold as it dries out. Firmly stick the gummed tape along each side of the paper, with about half the tape width on the paper and half on the board. Press out along the tape's length, using a dry rag or kitchen roll, to ensure it is secure, and then place the board on a flat surface and leave to dry for a few hours or overnight. If you have a few boards, you can stretch a few sheets at a time so that you have a ready supply of stretched paper to hand.

brushes

Most art shops stock brushes for all forms and styles of painting, and when you go in there you will most likely find them grouped together in one big rack. Only a small proportion of these are for watercolour, and even then you will only need a few of those offered – in fact, if you have to work on an extreme budget you can get away with using just one brush. The brushes I use most are:

- a 25mm (1in) flat wash brush for laying down broad expanses of paint
- Nos. 12, 10, 8, 6 and 4 round brushes for most other painting techniques
- a size 1 rigger brush for fine detailed work.

choosing brushes

Manufacturers make brushes with different types of hair or fibre. The cheaper ones on the market are made from man-made fibres, such as nylon, while the more expensive are made from animal hairs of varying quality. The bare facts are that natural hair holds far more liquid than a man-made fibre, therefore a brush of animal hair can put more paint on to the paper in one go. You could argue forever about the pros and cons, and whether or not we should ethically use animal hair – I once made a brush with hair groomed from my cat. She wasn't bothered, but the brush was rubbish!

On the right is a brief and generalized overview of the different qualities found in brushes. If you are unsure, ask the person who is selling the brush; some shops allow you to try out brushes with clean water before you buy. Try out a range of different brushes, and stick to what you find comfortable to work with.

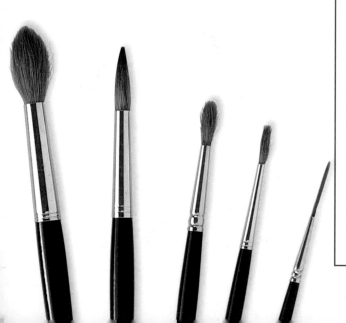

types of brush hair

synthetic or man-made
These are OK for starting with. The brush should say 'synthetic' on it, but if it doesn't, look at the name – does it end in a synthetic-sounding word such as 'ene' or 'on'? The low price is often a giveaway. Man-made fibres have a very low water-retention rate, therefore a nylon or synthetic brush won't hold much paint, so you have to constantly recharge the brush for larger washes. As you progress, you may wish to upgrade to better brushes.

synthetic and hair mixes or blends
These are the best middle-of-the-range brushes. They combine the springy qualities of synthetic fibres with softer, more water-retentive natural hairs, resulting in a brush that can hold lots of paint yet is still relatively inexpensive.

squirrel or camel hair
Fairly cheap and very useful, these are soft-haired and make beautiful wash brushes. Although they don't generally spring very well, they do hold vast amounts of water, making them useful for applying large amounts of paint in one go, such as in a large sky area. You normally find these hair types in large flat brushes, mops, hakes and occasionally round brushes.

sable
Sable brushes are generally marketed as the best brushes for watercolour. Sable hair comes in different grades and qualities, and this can affect the standard of the end result. Sables can be expensive, and it would be fair to say that the quality of the brush is usually reflected in the price.

kolinsky sable
These are by far the best for watercolour work: they hold lots of paint and can produce everything from a broad wash right down to a very fine line in one continuous brushstroke. A good Kolinsky sable holds a very fine point and is beautifully soft and springy – but it can also be very expensive!

red sable
Red sable is slightly shorter than Kolinsky, and as a consequence the brush head or tuft is usually shorter and more rounded in a round brush. This means that while the brush holds lots of paint, it may be difficult to achieve a very fine point for detail work.

brushes to avoid

Time and again I come across people inadvertently using the wrong brushes for watercolour. Avoid the following types of brush:

- Oil or hog brushes: stiff-haired brushes for brushing oil paints and acrylics on to canvas and boards. The bristles are very coarse.
- Synthetic hog brushes: these man-made brushes are unsuitable for watercolour use because of the stiffness of the fibres. If the tuft of the brush doesn't feel soft, don't use it for watercolour.
- Fan brushes: shaped like an opened fan, these are useful for blending areas of oil paintings, although some manufacturers produce them for use in watercolour. There is nothing you can do with a fan brush that you cannot do with any other watercolour brush: I bought a fan brush in my early years, and I still haven't used it.

The brushes that you use are directly related to how you apply your paint to the paper and consequently how that paint behaves. Always buy the best brush that you can afford, and if that means buying one good one as opposed to several cheaper ones, then do it. If you use old, worn brushes or cheap, disposable ones, you really can't expect to achieve good results.

other materials

There are many items that are adaptable for painting in watercolour, some of which are listed here.

- A tool box or gardening box is useful for keeping all your materials together.
- An easel is fairly unnecessary for watercolour, because you can prop your work on books on a table top.
- Palettes can often be expensive and have little room on which to mix. I use a white plastic food tray for mixing my colours. I also use a decorator's paint kettle as a water pot so that painting water doesn't become dirty too soon.
- Glass jars are useful for holding clean water and are easily obtainable. Try using two – one for clean water and one for rinsing.

watercolour mediums

Mediums you may come across for watercolour painting include:

masking fluid

This rubbery solution is painted on the parts of your painting that you wish to retain as white paper. It takes a short while to set, and then you can paint any number of washes over it. When your washes have dried, peel off the masking fluid to reveal a crisp white area. Masking fluid can also be used to mask an area that has already been painted, although it can sometimes take off some of the colour when it is removed. Avoid using your best brush to apply the medium, as it can gum up the hairs if you don't wash it out immediately after use.

masking film

This is a clear, low-tack adhesive film for masking out larger areas. It used to be used in design studios, but with the growth of the computer, masking film is not so much in demand any more. If you can find it, then it does have a use for watercolour painting.

masking tape

This has many uses, from sticking down unstretched paper to masking straight edges and borders.

gum arabic

This increases the gloss and transparency of watercolours.

ox gall liquid

This increases the wetting and flow of watercolours.

Advancing technology means that new additive products, such as blending, texture and iridescent mediums, are gradually being introduced. If you wish to try these products, do so by all means; but in my opinion you cannot beat the traditional skill of using just paint, water and paper.

washes

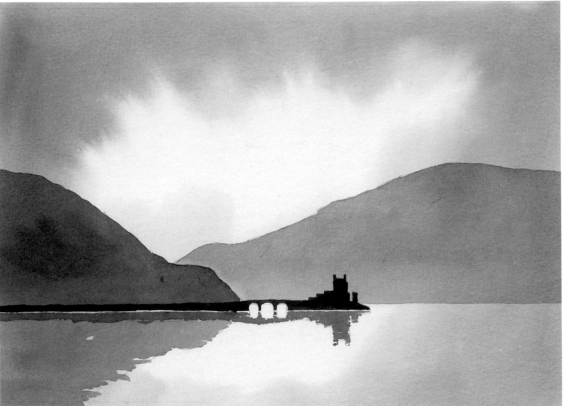

Now that you know a little about the properties of watercolour and the materials used, it is time to start painting. Your first exercise is to have a go at painting the scene illustrated here. I have deliberately given you no instruction, although I have illustrated a number of steps on page 58 to give you some guidance with the construction of the painting – but try not to use these at this stage.

By the time you have finished your own version you should have raised many questions, anxieties, doubts, fears and delights relating to the application of the paint, mixing the colours, drying times and so on. Apart from that, however, this is your first painting, so be proud of it (whatever the result may be) and don't throw it away. You can use it to compare with subsequent paintings, and this should give you the confidence to progress.

Before you embark on another exercise, it is important to grasp the idea of washes and how to control paint; you have probably discovered this already! Watercolour needs to be laid down methodically as a continuous wet sheet, and this is the important bit – it needs to be evenly wet as it settles. Any break in continuity, for example inconsistent brushloads, will only induce streaks, brushmarks and runbacks in the wash. (Runbacks are cauliflower shapes or blooms caused by uneven wetness and varying drying rates. You will spot one at some stage.)

basic wash techniques

A wash is the term used for an application of paint, and layers of washes, laid over each other, characterize the appearance of a watercolour painting. To gain the correct flow of paint you must first tilt your board or pad towards you at an angle of roughly 20–40°.

Always mix up your colours before you start. Mix your paint with water to the consistency of milk, and mix more than you think you will need, usually double the amount of your first estimation – honestly, you will use it. If you use too much water and not enough paint, your wash will be barely visible, and if you use too much paint and not enough water, your wash may not flow correctly, resulting in stripe after stripe of thick, dry paint. Any pauses while applying a wash can cause problems with the way the paint settles, so keep going until you have finished the area. Try these exercises in small areas: about 15 x 10cm (6 x 4in).

flat wash

A flat wash is an evenly applied mixture of paint that leaves a nice flat colour with no blemishes on the paper. To achieve this you need a quantity of ready-mixed paint and a large round brush (No. 10 or 12) or a 12–25mm (½–1in) flat brush.

Make sure your board is angled towards you, then load the brush with paint so that it is full; do not remove any of this paint. In one continuous stroke draw the brush across the top of the paper from left to right; if you are left-handed, you may find it more comfortable to work from right to left.

When you have reached the end, recharge your brush with paint and work this time from the opposite side, right to left (left-handers go left to right). Overlap the brushstroke halfway into the line you have just made (which should still be wet), and repeat the process alternating right to left, left to right until you have reached the bottom of the wash area.

Keep your eye on the line of paint that builds up at the bottom edge of each brushstroke, as this is a good guide to the amount of paint you are using. If you use too much paint, this line, or reservoir, will overflow and run down the paper; while if you use too little paint, there won't be a reservoir visible and your wash will dry between strokes, resulting in a streaky finish. The reservoir is paramount to keeping a wet edge to the wash.

At the bottom of the wash, squeeze out the excess paint from the brush and draw it along the reservoir to soak it up.

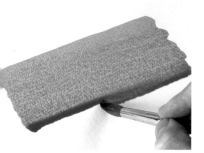

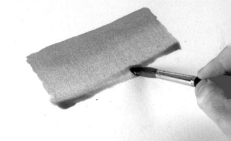

gradated wash

This is an application of pigment that gently fades away to nothing as it reaches the bottom of the wash. The technique of applying the paint is exactly the same as the flat wash, only instead of painting the same strength of colour on every line, you need to gradually dilute your colour with clear water for each brushstroke.

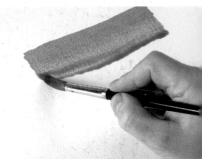

Mix a pool of colour and load the brush. Begin in the same way as a flat wash for the first few strokes, then after each pass mix a brushful of water with your pool of paint and continue working your way down the paper. The process should go something like this: paint applied to paper left to right, add water to paint in the palette, paint applied to paper right to left, add water to paint in the palette, paint applied to paper left to right, and so on.

Repeat this process until you reach the bottom of the page or run out of colour. Either way, the result should be a nicely gradated wash, from colour at the top to clear at the bottom.

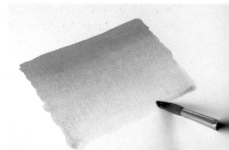

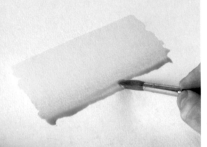

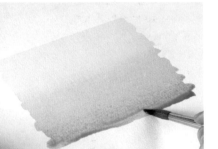

variegated wash

This technique involves two or more colours, which are gently blended together as the wash progresses. Once again, good preparation is the key.

Start by creating two separate pools of colour, for example a yellow and a green, and then begin to lay a flat wash of yellow at the top of the paper. In the same manner that you applied the gradated wash, for each stroke add a brushful of green to the yellow (in the gradated wash you added clear water). The process should go something like this: yellow applied to paper left to right, add green to yellow in palette, paint applied to paper right to left, add green to yellow in palette, paint applied to paper left to right, and so on.

Working down the paper, the green should eventually take over the yellow; however, you may need to cheat a little here and switch to using just pure green as you approach the bottom of the wash, to be left with a gradation from yellow at the top to green at the bottom.

wet-into-wet

This is the most exciting of watercolour techniques. Wet-into-wet is the application of wet paint on to wet paper, and means that you can blend colours in a very subtle way and create fantastic atmospheres with just a few strokes of the brush. As always, prepare everything before painting: have pools of colour ready mixed, and make sure you have plenty of clean water.

Using a large brush, wet the paper surface thoroughly with clean water and allow it to settle for about a minute while the paper absorbs it.

Now rewet the area, brushing the water in all directions and keeping the brush in constant contact with the paper so that it appears to be evenly wet. You can check the sheen by looking at it against the light: if there are signs of drying off, you need to add more water, and conversely, if you see standing water and puddling, this is too much, so take some off with the brush. Aim to achieve an even, satin sheen before applying your paint.

Use less paint with this technique than with others: load the brush, then take out much of the volume by dragging it over the side of the palette or dabbing it on tissue. As you brush the paint on, note how it bleeds away and creates lovely soft edges. This technique is very versatile, but it can be unpredictable.

tip
Experiment with how much you tilt your board to achieve different effects with wet-into-wet technique.

washes and your paintings

These wash exercises are intended to help you control the flow of paint on paper, but they aren't necessarily the way you will always paint; look on them as musical scales practised on an instrument.

Once you are familiar with the rules of handling a wash, try to speed up the process and loosen up any tight brush control. Try laying a flat wash with a large brush, slapping the paint on almost as though you were painting a wall, but retaining full control of the flow. Keep an even spread of paint by using the brush on its side and in constant contact with the paper (until you need to recharge it). Although this technique is loose and spontaneous, you must always work to a wet edge. Working this way brings much more life to a wash, and in time it will free up your style.

Try all the wash exercises again, first in the controlled, strict-exercise manner and then with a looser approach. Compare your results and think about how you feel while you are painting. You may feel very tight and restricted when following the initial exercises, and you may experience excitement and spontaneity as you quickly scrub on the paint on your second attempt. Do plenty of work on these exercises because they are the key to successful watercolours. Remember: loose but controlled is best.

Now take a look at some of my paintings throughout the book. Consider the relevance of the basic washes, and look out for them in the paintings. Look in particular at how they might have been painted, as well as which washes I have used, where, and why. Before you tackle another painting, stop and think about the washes you might use and where you might use them.

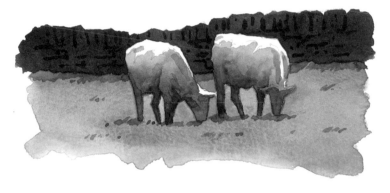

going further

Now you have worked through the washes, it's time to take stock. It will take a while before you are fully experienced in handling paint proficiently and confidently, so take up every opportunity to practise – and keep on practising. You will gain experience and confidence as you progress, so try to be realistic about your own time scales for improving. Keep working at it, and never put yourself down: you may have watched a professional artist produce a stunning painting within an hour, but it may have taken him or her 20 or 30 years to learn how to do it that way. Practice, enjoyment and enthusiasm are the key driving forces.

pointers to watch for with wet-into-wet

- When using wet-into-wet, always make sure that you have less fluid on your brush than for other washes.

- Make your paint stronger than you need. Wet paper will effectively dilute any added paint, and your wet-into-wet wash will dry much lighter than you may want.

- Different wet-into-wet effects can be achieved in a variety of ways: for instance, tilting the board at a shallower or steeper angle reduces or increases the speed of the flow of paint. Similarly, using more water, either on the paper or mixed with the paint, produces varied effects, especially when combined with different board angles.

- The main point to remember is that if you add paint that is more fluid than the wash or water on the paper, you will more than likely end up with runbacks.

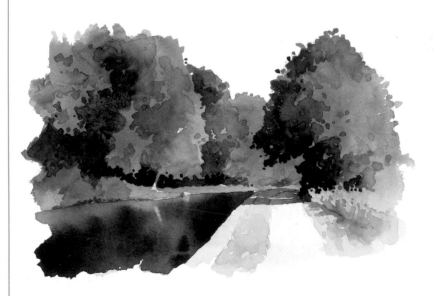

brushstrokes

There are many different ways of handling a brush and many different techniques you can use to create many different effects. Your brushes are important tools, so experiment with them and see what works for you.

Before you begin these exercises, make sure you are holding the brush between your thumb and forefinger rather like a pen or pencil. Grip the shaft of the brush somewhere around or near the top of the ferrule, the metal part that holds the bristles on to the handle. Try to get into the habit of resting or extending the side of your hand – or better still, your little finger – on to the painting surface, as this helps to give your hand balance, which is essential for controlling your brush.

The main control that you need to establish is being able to apply varying pressures to the paper. This sounds easy, but when you find yourself painting up to an edge with your arm moving left to right and right to left like a typewriter and your thumb and forefinger applying various amounts of pressure to the brush while watching a critical edge below, then you realize that it is not as simple as it seems: it is like trying to pat your head and rub your stomach at the same time.

Start with these basic exercises and try to control the varying pressures. Some of the holds and ways of gripping things may seem a little alien at first, but keep practising and they will begin to feel more natural.

pressure-control strokes

Assume the hold and then lock your wrist so that your whole forearm, from the brush to your elbow, is straight. With a loaded brush, draw a smooth line across the top of the paper as with a pen or pencil, but using the flow of the whole arm. Don't forget to use the little finger on the paper to control the pressure. This may feel a little stifled to start with, as you will be concentrating on your arm, your wrist, your little finger and your grip on the brush. Don't worry, just keep doing it, and in time it will begin to feel natural.

Now try to concentrate on using your little finger as a buffer. The pressure or weight applied to the brush can be controlled by anchoring the hand to the paper through the little finger. Repeat the first exercise, but this time as you pass the brush across the paper, try to regulate the pressure gently from heavy to light. To do this, keep the wrist locked and move the brush up and down using the thumb and forefinger only, keeping the little finger in contact with the paper. This requires great dexterity and is not easy at first. Once you begin to feel the control, try again without locking your wrist or putting your little finger down. You will be able to feel the difference.

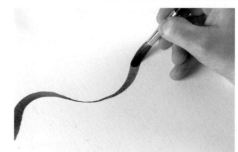

Staying with the pressure-control stroke, add another direction to the movement. As you gradually move your arm across the paper, create an undulating, gently curving line by slowly moving the whole forearm up and down at the same time as applying greater and lesser pressure through the thumb and forefinger.

drybrush

The drybrush stroke is pretty much self-explanatory, as it means using a brush with very little paint on it. Drybrush is excellent for describing many different textures, including ground textures and the varying effects of sparkling water. In a single brushstroke the paint hits and misses the granulation in the paper, and it is most effective when it is used on rough-surfaced watercolour paper.

Load a large round brush (say, No. 12) with paint and then remove some of it by dragging the brush over the side of the palette. Lower the brush flat to the paper so that the belly of the brush touches the paper surface but the point doesn't; you can either tilt the hand upside down or hold the brush from above, as though you were picking it up.

Drag the brush across the paper in the direction that the shaft is pointing. If you have problems, these could be due to a number of factors: a slim brush or one without a belly (usually synthetic) can make life difficult here; some papers are more responsive than others; and the brushstroke can be difficult to achieve on top of a painted surface on some papers. If you are repeatedly achieving fine train lines in your drybrush effects, it is likely that the point is coming into contact with the paper.

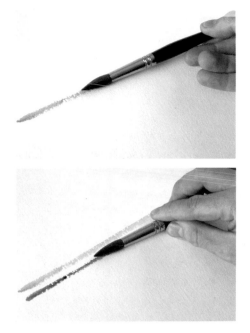

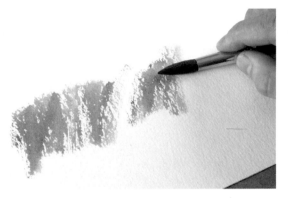

scumbling

This is a decorator's term that describes the brushstroke well. It is similar to a dry brushstroke in that you keep the brush low to the paper, but you can use a little more paint here.

Using the side of the brush, scrub the paint around in different directions, using a quick, random approach. This is ideal for suggesting texture and works well when painting summer trees, skies, mist and rough ground.

stippling

This is another decorating term. Holding the brush vertically, gently dot the paper with the brush about half full of paint. Varying the pressure used (keep your little finger in contact with the paper, and apply the pressure through your thumb and forefinger), you can achieve larger and smaller dots, ideal for suggesting leaves on a tree or stones, pebbles and other textures.

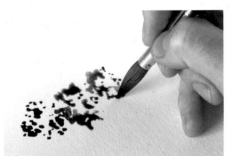

using a rigger brush

Rigger brushes are extremely useful for creating very fine lines and drawing details into a painting. Load the brush and try to keep it upright so that you utilize the very tip; again, use your little finger to give full control of the pressure applied. I find a rigger extremely useful for painting twigs and branches in winter trees or fine detail in a drystone wall.

using a flat brush

Flat brushes, mops and hakes are all great for putting down large quantities of paint in a short space of time, for instance in a big sky area. Simply load the brush with paint and brush it on using the full width of the brush, remembering to recharge it with paint the moment it is empty.

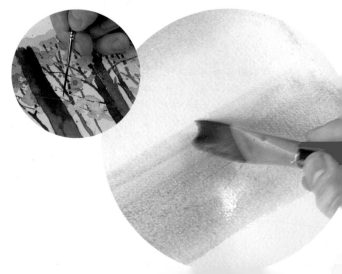

when to use smaller brushes

Use smaller brushes for everything from medium-sized washes down to tiny details. The size of brush is relative to the size of wash you are creating. As a guide, if you have to recharge your brush as soon as you touch the brush to the paper or if your wash is drying as you put it on, you probably need to increase the brush size. If the brush unloads too much paint, making detail painting difficult or creating blobby areas, either reduce the size of your brush or take some of the paint out of it.

when to use a big brush

Use a big brush, such as a No. 12 round or a 25mm (1in) flat, on large areas where you wish to put on lots of paint quickly, for example a sky area or a large colour wash for a group of mountains or a big land mass. Whatever it is you are painting, remember you need to get flowing paint on as quickly and with as much control as you can in order to avoid varying drying rates, streaky washes and runbacks. For a big, loose wash, load the brush full and load again as soon as all the paint has been discharged. If you are painting around a tight area, try removing some of the paint from the brush to avoid puddling or, better still, change to a smaller brush size to gain greater control. As soon as you have painted around the obstacle, you can go back to the big brush.

This study incorporates each of the various brushstrokes shown on the previous pages. These techniques can be used for many different effects in watercolour painting, and it is often better to use a simple brushstroke instead of slavishly copying precise details.

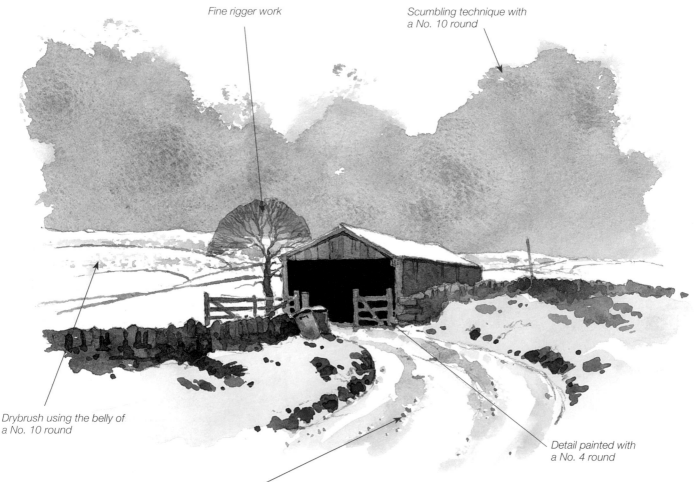

Fine rigger work

Scumbling technique with a No. 10 round

Drybrush using the belly of a No. 10 round

Detail painted with a No. 4 round

Stippling with a No. 8 round

colour

Many people dismiss the comprehension of colour mixing, either because they find the subject uninteresting or they can't understand the theory. It looks complex, but it really doesn't need to be. First, take a close look at the colour wheel below.

There are three colours that cannot be made from anything else and from which all other colours originate. These are the parent colours, and you probably already know them as primary colours: red, yellow and blue. When mixed together in pairs, these colours form three new colours – green, orange and violet – known as secondary colours. A secondary colour mixed with a primary forms a tertiary colour; these tertiaries aren't really new or different colours, they are just steps between primary and secondary colours.

These are all the colours you will ever need. Look at the colour wheel again to see how all these colours form the spectrum.

Q&A

'I have Payne's grey, which is almost black, but what if I want a blue-grey? I don't see one of those in my paint set.'

Just look at the words in the colour description: blue and grey. You can mix Payne's grey with any blue – Prussian, cobalt, French ultramarine and so on – to create a variety of blue-greys. Similarly with green: you can create grey-greens, blue-greens, yellow-greens and so on just by mixing a tube or pan green with other colours.

'How do I know which palette colours will mix together to create the colours I want?'

To be able to mix colours together successfully, you need to know where they lie on the colour wheel. I have placed a number of popular colours on the colour wheel, according to their individual colour properties. You can immediately see which palette colours are complementary (opposites), which are primary colours (or near to primary), which ones are secondary and which are tertiary. Taking French ultramarine as an example, although it is blue in appearance, when it is compared to a primary blue it is a slightly different colour. This is because French ultramarine contains a small amount of red and therefore sits between blue and violet as a blue-violet (tertiary). Its complementary colour is burnt sienna (or thereabouts).

To work out the colour properties of your own colours, you need to obtain the three pure primaries. Most manufacturers produce colour charts on which the primaries should be marked. Paint a swatch of each primary and a swatch of each of your palette colours, compare them and then estimate their colour properties. For example, try to work out if a given blue is a pure blue, a blue containing yellow or a blue containing red. You can then position that colour on to the colour wheel to give you an idea of how it will behave with other colours.

'If the primaries can create all other colours, does this mean that I can create a painting using only red, yellow and blue?'
Yes, you can. In fact, it is worth having a go, because it will teach you so much about colour mixing.

'If I only need three colours, why are there so many different colours in my paint set?'
All the colours contained in a paint set are directly related to the three primaries, and you can technically mix them all yourself from these three parent colours. However, the colours in paint sets have been developed to replicate common colours found in nature, so look at them as shortcuts to popular primary mixes, rather than a mixed bag of disparate colours. For instance, to create a large wash of a colour similar to Payne's grey, you could spend time mixing three primaries to obtain the precise colour match; or you could just squeeze the colour directly out of a tube marked Payne's grey. However, note that some colours differ between manufacturers: for instance Payne's grey in one brand may be much bluer than another brand of the same colour name.

creating pale colour mixes

When mixing different strengths of colour or tone, there is a simple procedure to follow. In theory, lighter colours require you to add more water to the paint mix. The more you add, the paler it will go as more and more of the paper shows through the layer of paint.

Try it with a red. Pale this down gradually with water, and if you are painting on white paper you will find that you eventually create a pink. Start with a volume of water in the palette and gradually add small amounts of paint until the desired strength is acquired.

creating strong colour mixes

Stronger colours and tones require more paint, resulting in less of the paper showing through and therefore creating more colour intensity. In this instance you should use less water in the paint mix. To increase the volume of the colour mix, you need to use quite a large quantity of paint. This may seem rather obvious, but the temptation is to make the paint go further by increasing the volume with water, which will only result in a paler mix. To create stronger tones, begin with a generous amount of paint in the palette, and gradually add small amounts of water until the required strength is reached.

When mixing colours, try not to dwell too much on accuracy – you are not a chemist, you are an artist. I adopt the approach that if it is near enough it will be OK, and this works fine for me.

'Why isn't there a grey on the colour wheel?'
Greys are made by mixing complementary colours, the ones that are directly opposite each other on the colour wheel, for instance a red and a green, a blue and an orange and so on. Mixed in relatively equal quantities, they will create grey. By referring to the colour wheel, you have all the reference you need to create and alter those colours as required. Using complementary colours is great for creating shadows.

If you want to create a shadow over a yellow, for example, then you can mix a little violet with it to grey it off slightly. Likewise, if you were using violet you could use yellow as a mixer in order to grey it off. The same method of creating shadows in this way applies to the other examples shown here, all of which are complementary colours to each other.

80% lemon yellow

20% intense violet

Yellow-grey, ideal for shadow work on a yellow ground.

80% cobalt blue

20% cadmium red

Blue-grey. To create an orange-grey, switch the mix to 20% cobalt blue and 80% cadmium red.

80% crimson alizarin

20% Hooker's green

Red-grey. As with all complementary mixes, make sure the shadow colour is on the bias of the original colour.

mixing shadows

We can term shadows as areas out of the light that take on a neutral hue compared to the same colour seen in direct light. Capturing this effect is easy using complementary colours. First, look at the local colour on your paper: for example, you may have painted a green field using sap green. To create a shadow for the green, check your colour wheel and select a colour that is as near to its complementary as possible – for a sap green (yellow-green), choose something near to red-violet, such as alizarin crimson mixed with a little blue. Now mix up a quantity of sap green in your palette and add small amounts of the red-violet at a time until the colour turns into a grey-green. Don't overdo the red-violet, or your shadow will become tinted with red. Always keep the shadow colour on the bias of the original colour; in this case you are aiming for a neutralized green, not a grey. By starting the colour mix with green and adding small amounts of its complementary, you will reach the required colour much more quickly than the other way round.

Where you want to make a shadow fall across two or more different areas, always mix up shadow colours that relate to each individual area or change of colour that the shadows fall across: for instance, make up one shadow mix for a green field and another for a light-coloured path through it, referring to the colour wheel for each new colour. So long as you achieve the same strength of tone for all the shadow sections, you can then join the colours at the edges to make one continuous shadow.

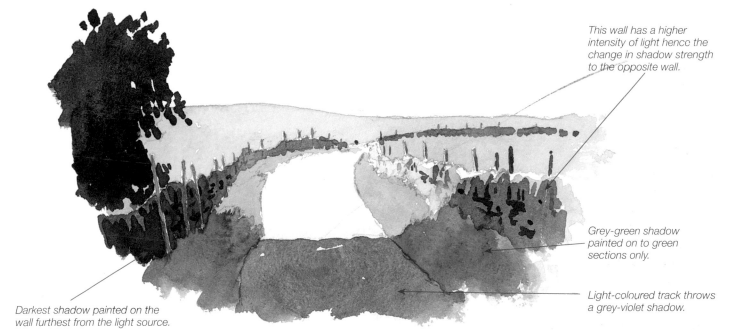

This wall has a higher intensity of light hence the change in shadow strength to the opposite wall.

Grey-green shadow painted on to green sections only.

Light-coloured track throws a grey-violet shadow.

Darkest shadow painted on the wall furthest from the light source.

mixing greens

It is easy to become confused when painting greens, probably because of the huge variety that are generally seen in nature. Don't try to capture every hue; keep things simple by using one green and altering its properties by adding blue for cool blue-greens and yellow for warmer yellow-greens. An addition of a complementary will create a grey-green, and this should provide you with enough interest and tone to create a whole range of greens in a painting.

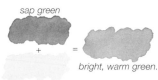

sap green

+

lemon yellow

= *bright, warm green.*

sap green

+

cobalt blue

= *cool green, ideal for greens in the distance.*

sap green

+

French ultramarine + light red (mixed)

= *dark grey-green, ideal for shadows.*

seasonal palettes

As the seasons change so the appearance of the landscape changes, and this provides an enormous amount of diversity for the artist – personally I find the crisp, translucent shapes of summer trees just as exciting to paint as the barren canopies of their winter form.

Take note of the seasonal characteristics of the landscape, and pick up on the different colour palettes – blues and greys in winter, warm greens and yellows in spring and summer, and the reds and browns of autumn.

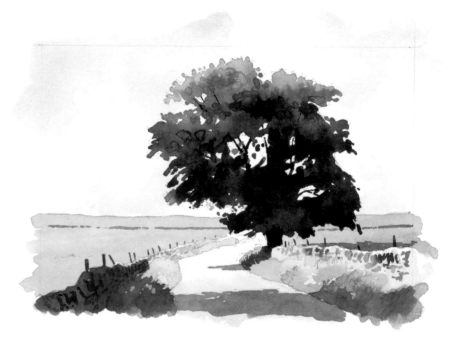

summer

Summer means dealing with many different greens, together with strong lighting effects and contrasting tones. Make use of cool shadows to enhance warm colours along with areas of darker shade, to help increase the brilliance of lighter areas. Areas of shadow and dappled light really enhance a summer scene, especially when it is lit from one side.

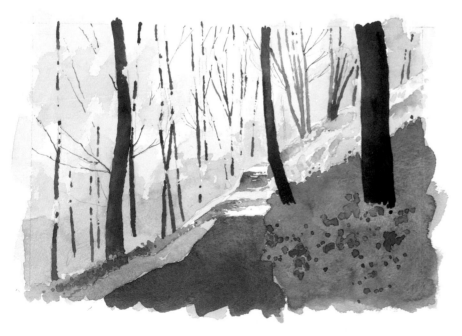

spring

Spring brings about a freshness to the landscape, and at this time of year I like to seek out woodland subjects peppered with wild flowers, lit by the remnants of low, clear winter light. The landscape is a shcer joy between late February and April.

autumn

Autumn time is synonymous with woodland and the fantastic colours of leaves, so it pays to study trees as much as you can. Use a warm, rustic selection of colours: cadmium red and yellow, light red, burnt sienna, sap green and lemon yellow. Autumn light is normally very warm and casts a golden hue over the landscape, so look out for these effects and pick up on them by adding a warm yellow into your colour mixes.

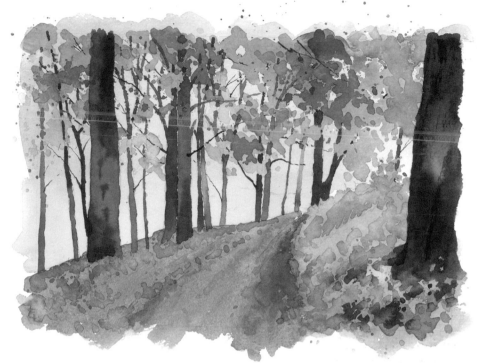

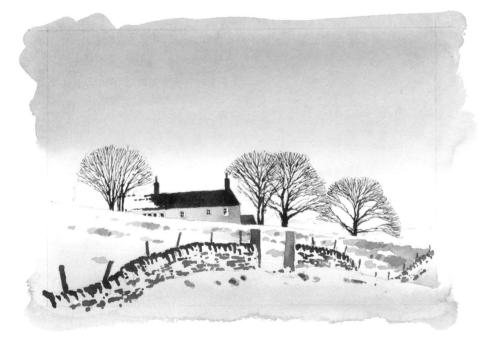

winter

For me, winter is the best time of the year, not only for subjects but also for the light. Winter light is unbeatable for its clarity and its ability to form exciting shadows due to the low level of the sun. Snow changes the landscape completely and brings about many scenes full of contrast. Cool colours often dominate, although it is always rewarding to seek out contrasts where warmer colours help to emphasize the coolness of the shadows and surrounding landscape.

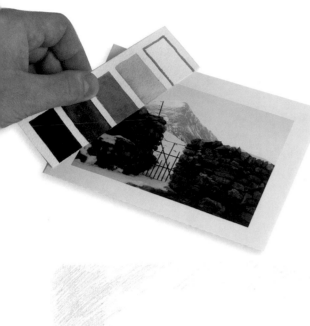

tone

Tone is one of the most difficult subjects in painting, but in order to attain three-dimensional effects or to create striking impact in your work, you should not ignore it. Tone refers to the strength of colours, and it is this that defines and separates edges in your work.

reading tonal values

The first skill to work on is reading and transposing tonal values from the scene or photograph you are working from into your painting. A very effective way is to screw up your eyes to the point where they are almost shut: this intensifies the tones, blocking out distracting detail and, to a certain extent, colour. With photographs, you can make black-and-white photocopies in order to see the tones more easily, or run them through a photo-editing program on your computer. What you are looking for are the lights and darks within the scene, as ascertaining the lightest part of the scene gives you your starting point.

An excellent aid for transposing tones into your painting is to use a tonal finder or tonal strip. You may be able to purchase one of these, or you can make one yourself from a strip of watercolour paper. Paint a series of five tones ranging from white paper to the darkest dark, using a strong neutral colour such as Payne's grey. By placing this alongside your photograph or scene, you can compare the tones to those painted on the strip. To transfer the tone to your painting, compare the same value to that on your scene; you will instantly see whether your tone needs to be darkened or lightened.

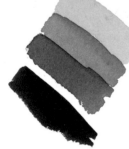

creating a range of tones

There are three main ways of building up gradations of tone in a watercolour. One is to use a wet-into-wet technique, where you put down a wash of clear water and gradually add paint, making it stronger as you go. Another is to paint the tones in solid blocks, a light block here, a dark block there. The third way is to use an overlayering technique, allowing the washes to dry in between: this method is very versatile, as you can build up different tones, textures and 3D effects all at the same time.

Practise these techniques on a piece of watercolour paper. In the wet-into-wet technique, wet the paper then keep adding paint in increasing strengths. In the second example, create five tones in a strip by blocking in the individual tonal strengths; for this you need to mix the correct density of paint in the palette for each individual tone. The third way follows the conventional method of building up a watercolour by layering tones like sheets of tinted glass; for each layer create a new strength of tone in your palette to match a tone created on your paper.

Paint on the mid-light tone, leaving an area of white paper. Let this dry and then mix a tone in your palette to match the tone on the paper and overpaint it, this time leaving a section of the mid-light tone showing. Note that the strength of the overlaid tone increases: this is because the tone on the paper is showing through the new tone, effectively doubling itself in strength. Continue with the scale, matching each new tone. By the time you have created five tones you should have achieved both tonal extremes and a small range of mid-tones.

Wet-into-wet creates an instant range of tones, ideal for the soft gradations of a sky.

Blocking in tones: ideal for creating contrast.

Layering tones: ideal for increasing tone and detail at the same time.

planning your tones

It is a good idea to plan the tonal structure of your work before you begin to paint, to avoid making too many changes on the paper. Don't worry too much about this – as you progress you will want to improve your work. Try to use only the five tones in your paintings and categorize those tones from which you are working. So for instance, when viewing a scene or photograph, ask yourself whether the tone you are trying to copy fits the category of light, mid-light, mid, mid-dark or dark. Don't try to be too precise, or you'll be there all day. I usually formulate a tonal plan, either in pencil or as a quick watercolour monochrome to give me the reference I need while I am painting the finished artwork.

using contrast

Contrast is achieved by placing light tones adjacent to dark tones, the maximum contrast being the lightest tone placed next to the darkest tone. By using contrast effectively you can create striking effects that draw the eye to the painting. With this in mind, it is often beneficial to use contrast either on or around the main focus of your scene.

building up tones in blocks

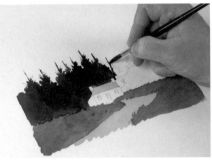

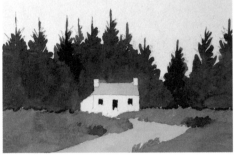

controlling tones

It is extremely difficult trying to read, manipulate and control tones in a painting, so keep practising this because it is so important. A great way of learning how to control tones is to work on simple exercises in monochrome. Work through the exercises on the right first (I used Payne's grey) and then have a go at inventing your own, considering the pattern of building up the tonal strengths for each section.

To build up tones in blocks, start by applying the palest colour in the picture as a very light wash. When this has dried, strengthen the wash and block in the next darkest areas – here the verges. With a much stronger wash, paint the trees as silhouettes, and then block in the windows and doors with an even stronger wash.

When overlayering, paint the lightest tone over all the areas to be painted (except the face of the building and chimneys), and allow to dry. The next wash takes in the trees and the verge at once; when this is dry, use a stronger mix for the trees and contours, finishing with the darkest tone for the details.

building up tones by overlayering

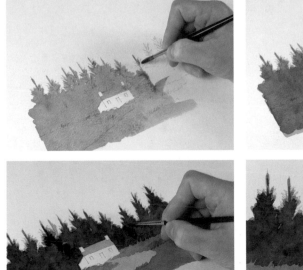

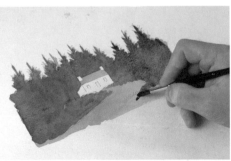

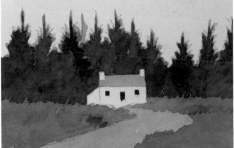

further techniques

Traditional watercolour painting essentially encompasses putting water-based paint on to paper with a brush, but there are other ways and techniques of applying paint, as well as using additives to create further effects in your work. Here are listed some commonly used techniques and effects that can help to enhance your paintings.

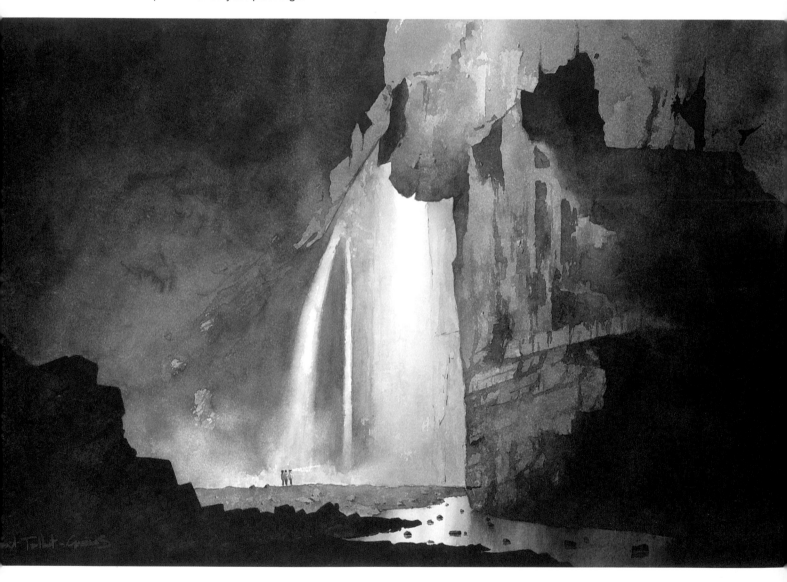

Gaping Gill Main Chamber, *33 x 50.8cm (13 x 20in)*
This painting utilizes some of the techniques that I have highlighted within this chapter. Any alternative method will complement the more traditional approach to painting, so always keep an open mind as to how you might tackle a subject. In this painting of Gaping Gill main chamber, the spray and mist effects from the waterfalls were scrubbed out quite vigorously with a damp sponge, glazed over with colour and scrubbed out again. The bright beam of the caver's head torch was scraped out with a blade once the painting had dried. Paint doesn't just have to be applied, it can be taken off and manipulated to your advantage.

removing paint

Taking paint off is often seen as a negative technique associated with correcting areas that may have gone wrong, but this method can also be used to create misty effects and highlights in a watercolour. You can take paint off using a dampened sponge, brush, tissue or cloth while the wash is wet or dry.

When removing paint from a wet wash with a damp brush or sponge, make sure that you remove most of the water from them first, otherwise you will produce runbacks. This technique creates soft edges on the removed area; for example, a soft-edged cloud can be removed from a wet sky wash with a damp brush. For harder-edged clouds or misty areas, dab gently into the wet wash with screwed-up tissue.

To remove dried paint, gently scrub at the area with a dampened sponge or tissue. A wet sponge is very effective at taking off dry paint quickly, and varied effects can be achieved by altering the amount of pressure applied. Use a scrubbing action to remove bigger areas and a dabbing action to create misty, soft edges. Rinse the sponge frequently, and keep turning it to avoid rubbing the paint back in.

masking

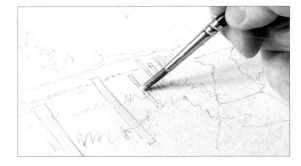

Masking is a very effective way of preserving an area of a painting from subsequent washes. Masking fluid has the capability of being painted to any shape; masking tape is great for creating straight edges; and masking film can be used to protect larger areas of a painting.

Masking fluid is available in yellow, blue and clear varieties, and is peeled off after use. You can mask white paper or even a painted area, although sometimes a little of the paint may disappear when the fluid is peeled off a painted area. When the fluid has dried on your painting, you can apply any number of washes over it. Apply masking fluid with an old brush, dip pen or stick. If you use a brush, wash it out immediately after use, as dry masking fluid is very difficult to remove from the brush hairs – and the same applies to your clothes!

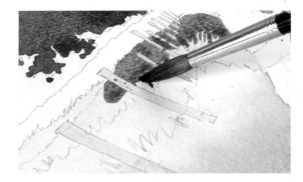

Masking tape or any low-tack tape can be used to mask off a straight edge such as a waterline or the outlines of a building. Sometimes masking tape can damage the surface of the paper, so try it on a scrap piece first. Masking film is a low-tack clear film, which can be cut to any shape and size. I sometimes use this to mask large areas of a landscape where fluid would be impractical.

glazing

A glaze is a thin mix of colour applied over a pre-painted area in a careful, flat-wash manner, in order to change the hue or tint of that area. Glazes can be useful for softening backgrounds or for unifying a light effect. A thin wash of French ultramarine laid over a background, for instance, will help to push it further into the distance and enhance the aerial perspective. The technique can be used as part of a deliberate plan or to help rectify a mistake. Take care if you lay a glaze over any heavily painted areas or fine detail work, as the action of brushing fluid paint over them may bleed those parts.

composition

Once you have the basics of handling watercolour, you can begin to explore the exciting world of creating your own paintings. If you have ever been attracted to a painting by an experienced artist and you find that you can comfortably look at that painting for a length of time, then it is most probable that the painting has been well composed.

what is composition?

Composition encompasses the arrangement of every element of a painting into a harmonious whole. Things such as the pattern of shapes, the balance of tones, colour schemes, atmosphere and lighting should all be given some thought before starting the painting, especially in watercolour. This is because the more you change and alter things while in the process of painting a watercolour, the more you may lose the fresh, crisp effect. It is therefore beneficial to compose and plan your picture before you even begin to put paint on to paper.

Composition should begin at the point where you collect your subject material. A conventional painting should ideally contain three grounds – foreground, mid-ground and background – although this isn't always necessary, and indeed it is very subjective to the scene you are painting. It is a good framework to start with, though, and you should look at your subject for a short while and decide what is your foreground, mid-ground and background.

Your chosen subject should also include a focal point or focal area, the part that hooks the viewer's gaze and holds their attention. A focal point could be anything that stands out, such as a figure, a tree, a patch of light, a post and so on. To attract the viewer into the painting and to the focal point you should ideally include some sort of lead-in. This is also subjective to the scene you are painting but could be anything relevant to the scene, such as a road, path, stream, river, line of puddles and so on.

what to look for

Look for the following in any of these combinations when you are next out in the landscape:

- A focal point first, followed by the three planes: foreground, mid-ground and background. Find and use a lead-in.
- A lead-in may attract your attention first. Follow this by looking for the foreground, mid-ground and background. Find a focal point to complete the scene.
- I usually look for the focal point first, then work outwards from there. Once you have become accustomed to these basic elements you may notice that your perception changes with regard to what makes a good painting and what doesn't. If you are working from one photograph that doesn't contain these important elements, it is unlikely to produce a stunning painting without a lot of creative intervention. Remember, not every scene will turn into a successful painting.

finding a scene

When out and about I usually have a camera with me, ready to record subjects and scenes. I also often carry a sketchbook and, if time permits, I sit and sketch the scene. This helps me to study and evaluate any areas that may not be entirely visible in a photograph. At this point it is important to note that not every scene you consider will make a successful painting, and it is also quite rare to find a naturally composed scene that requires no further alteration by the artist; you should therefore have an open mind when looking for subjects.

Some scenes may have all the potential of a good composition but lack a focal point. In these cases, it may be possible to borrow a focal point from elsewhere in the landscape and put it into your painting. Most of my landscape work is constructed in this way, using extra bits from elsewhere, removing unnecessary parts and maybe even exaggerating things such as the sky or lighting to make the scene appear more impressive.

Try not to look at the landscape as a confusing mass of objects, but instead break it down into simple elements and take a number of photographs from different angles, including close-ups and wider shots. Making a sketch integrates careful study of the subject with drawing practice, so don't automatically disregard your sketchpad and pencils.

composing your subject matter

When you begin to compose your painting, you will instantly realize the importance of having a number of photographs and sketches readily to hand. Although composition is a creative process that reflects the personality of the individual, there are one or two rules you should follow.

First, base the main framework for your composition around the Golden Mean. This is the division of your picture into three equal sections each way. Where each line intersects is where the eye naturally rests, and so it is beneficial to place the focus of your painting somewhere around one of these areas. Always avoid cutting your painting in half, in a visual sense: watch out for background hills creating a horizontal division, poles and posts creating a vertical division. Try to think in thirds, for example one third in, two thirds down and so on. If your focal point is central in the painting, place it just off centre. Half tends to distract the eye; thirds are best.

I usually begin my compositional workings with pencils and ordinary A4 paper. Working from anywhere between 150 x 100mm (6 x 4in) and the full size of the A4 sheet, I begin by drawing the focal point in the area that I want it. Working out from here and using rough shapes only, I construct the remainder of the scene, moving or omitting things as I see fit. All the time that I am composing I am mindful of keeping the focal point prominent. Having a number of different photos is extremely helpful, especially if I wish to change the angle of an object or move in close for the details.

When I feel happy with the arrangement of the shapes, I begin to work on the tonal aspects of the painting. Continuing with the drawing, I build up the tones with pencil according to the lighting

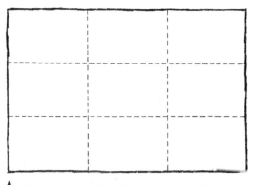

This is the Golden Mean division of a picture plane. Where the lines intersect is the optimum place for a focal point – the main thing to remember is to keep things off-centre.

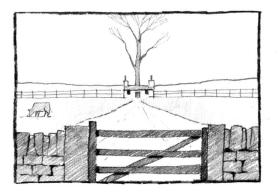

This illustration is an exaggerated but useful example of bad composition. The horizon cuts the picture in half and the building is placed dead centre with the tree behind cutting up the painting vertically. The straight fence line does nothing for the picture and the cow is facing out, not in. The wall and gate are nothing more than a visual stumbling block.

Here, I have lowered the horizon and placed the building to one side. The tree behind acts as a visual anchor and works much better in this position. For aesthetic effect, I have replaced the fence with a broken hedge line and twisted the lead in to involve more of the picture space. As a final point I have removed the cow, wall and gate – you don't have to put everything into a scene just because it is there.

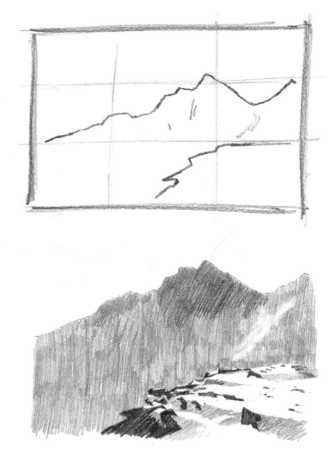

and atmosphere that I am aiming to capture; this often involves
a lot of trial and error, shading and erasing – even the sky can be-
come part of the overall composition, especially if it contains heavy
tones, big shapes or movement. I aim for balance in terms of tone,
trying to avoid one half light and one half dark.

Planning really does take up time, and this stage often takes
longer to work on than the actual painting process itself. What I do
achieve in the end, however, is a firm plan that I can refer to while
painting the scene. When the tonal plan is finished I consider the
colour scheme, if I haven't done this already.

Try to simplify the number of colours you use, as this will make
the painting process easier to handle. In doing this you may have
to substitute certain colours for reality, but this is usually accept-
able, as they will conform to your chosen colour scheme and not
what you see. The fewer the colours you use, the more harmoni-
ous the picture will be, so experiment with your colours first to see
if they work well together.

Here you can see my compositional progress from the initial
thumbnail idea to a more detailed tonal sketch and finally the
painting. I heightened the mountain slightly and introduced a
foreground from a photograph taken further up the ridge.

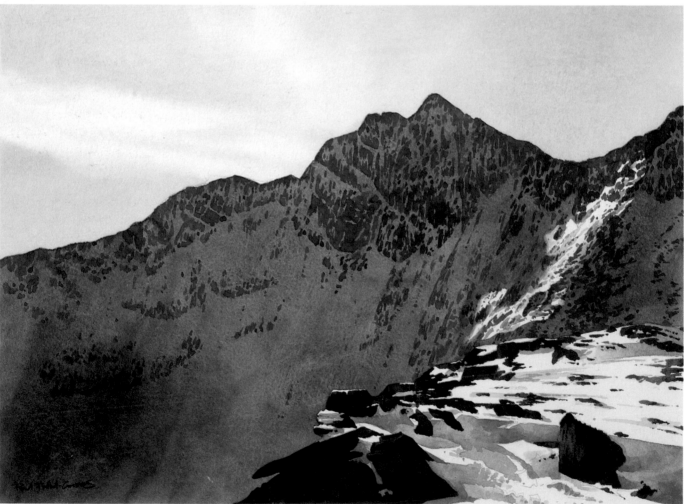

perspective

At some point you are bound to come across perspective in one form or another, whether in a painting or a sketch. Perspective can be difficult to grasp and many people try to avoid the subject, but the basics are fairly simple to understand. You only need to be aware of three forms of perspective: one-point perspective (otherwise known as parallel perspective), two-point perspective (otherwise known as oblique perspective) and aerial perspective. To draw anything in perspective, you first need to establish an eye level.

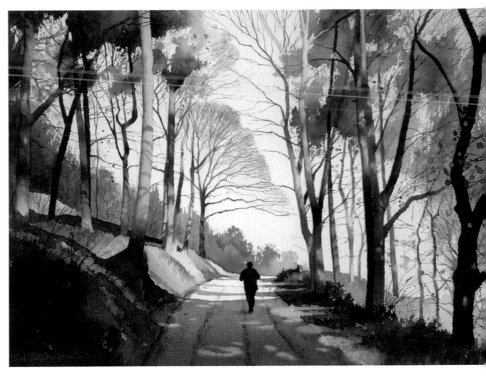

eye level

The eye level is the level at which you view your subject; this can be represented on a drawing by a horizontal line across the page. If you were crouching down, you would have a low eye level and your subject would be mainly above it; a normal eye level would be as though you were standing looking at the subject; and a high eye level would be as if you were dangling out of a first-floor window, looking down on your subject.

Somewhere along this eye level you need to establish either one or two vanishing points, depending on the perspective angle. A vanishing point is where the angled perspective lines eventually meet: the closer to the subject you are, the closer together the vanishing points are, and the further away you are, the further apart they are. In general, all the verticals should remain vertical.

Perspective isn't too important if you are painting landscapes without buildings and angles; however, an understanding of the basics will help in any situation. Even in this woodland scene, there is one-point perspective applied to the track and aerial perspective to the distance within the picture.

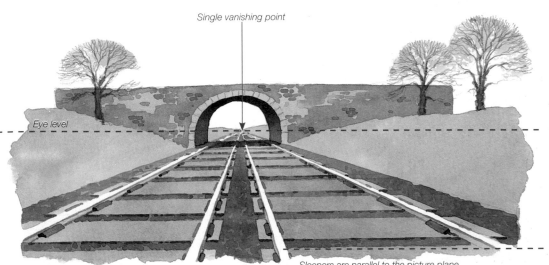

Single vanishing point

Eye level

Sleepers are parallel to the picture plane

One-point perspective showing the railway tracks converging at one point in the distance. One-point perspective occurs when one side of the object is parallel to the picture plane: in this instance all the sleepers run parallel to the bottom edge of the picture.

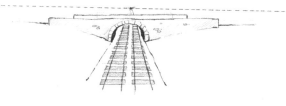

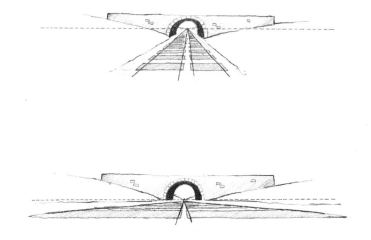

one-point perspective

One-point perspective (also called parallel perspective) occurs when one side of what you are facing is parallel to the picture plane. If you look down the centre of a railway line (preferably from the safety of a bridge!), you will see the lines gradually converging to a point in the distance. This point is the vanishing point (vp) from which all the receding lines radiate. In this case the sleepers of the railway line would be parallel to the picture plane, so you would draw the scene using one-point perspective.

The same phenomenon would occur if you were standing centrally at the back of a room facing the opposite wall. This wall would be parallel to the picture plane, and the side walls of the room would be in one-point perspective.

These illustrations show how the image is altered using different eye levels (represented on the drawings by the dotted lines). Top left has a high eye level, top an average eye level, and below a low eye level. Begin with the eye level, and the construction of the image will follow accordingly.

aerial perspective

Aerial perspective can be defined as the distance between the foreground and the background within a picture plane. In a landscape, far-reaching views are affected by light and water vapour in the atmosphere. As you look to the distance the air particles appear to be intensified, and this effect, combined with the reflection of ultraviolet light, creates a hazy, blue appearance, which varies with atmospheric conditions.

For the painter, this means that as things recede they generally become bluer or cooler in colour and much paler in tone; similarly, as things advance to the foreground they appear to be warmer in colour and much stronger in tone, and this is accompanied by an increase in visible details. To capture this effect, mix more blue and more water with your background colours in order to create aerial perspective in your painting.

Objects also decrease in size as they recede into the distance. A typical example of this can be seen in clouds: immediately above your viewpoint there may be big billowing clouds, but on the horizon they will appear smaller, closer together and generally cooler in colour. They are, of course, the same size, but they are affected by aerial perspective.

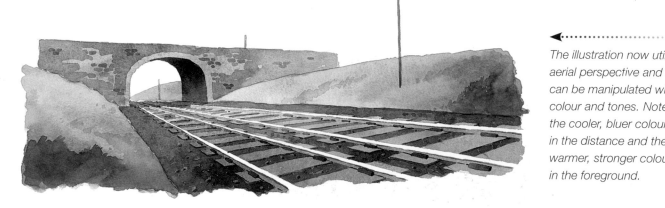

The illustration now utilizes aerial perspective and this can be manipulated with colour and tones. Note the cooler, bluer colours in the distance and the warmer, stronger colours in the foreground.

two-point perspective

Two-point perspective (also called oblique perspective) involves two sides of an object at different angles, which necessitates two vanishing points somewhere along the eye level. The lines for each side of the object will radiate from one or the other vanishing point; in this case, the sleepers are no longer parallel to the picture plane.

The closer the vanishing points are to the subject, the more acute the perspective will be. In most cases of landscapes viewed from a distance, the vanishing points are well off the page. With all this said, however, accuracy is not always necessary – so long as you understand the principles.

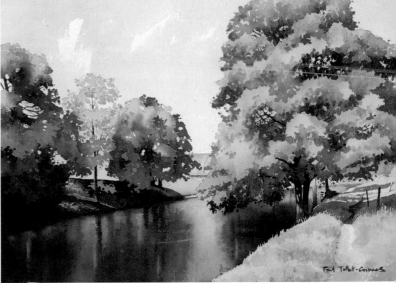

▲ *Changes in perspective can be subtle too. Here, there is obvious perspective in the line of the river, but in order to separate distance from foreground in this bright scene I have used more blue-green and less detail in the background trees than the one nearest the foreground.*

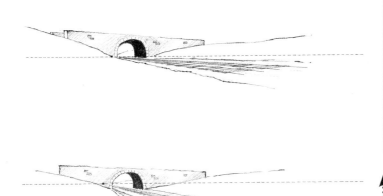

Note how this image differs from the one-point perspective version. Now we are viewing two sides of the railway sleepers, so two vanishing points have
▼ *been used.*

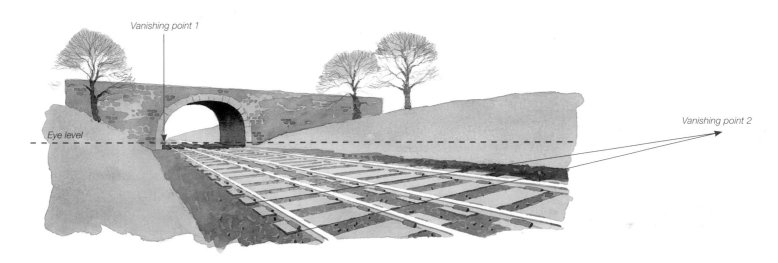

editing pictures

It is not necessary to put everything you see into your painting, so consider simplifying the scene by omitting certain features or moving them. The amount of alteration depends on the content and what you personally want to achieve, so follow the ground rules but at the same time use your freedom of style and personality in the creation of your work.

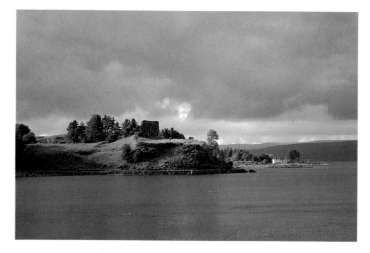

Photo: *I took this photograph because of the fleeting light and the atmosphere of the sky. Before I turned the image into a painting I needed to decide on one focal point: should it be the castle or the white building in the distance? This is where decisions like this make all the difference to your work.*

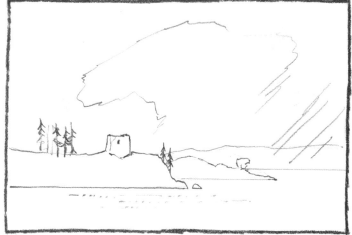

Linear composition: *Initially I worked in line, constructing shapes and altering the appearance of the scene. Note how I have lowered the land to place greater emphasis on the sky, simplified the trees and adjusted the shapes within the sky to bring the eye into the focal point.*

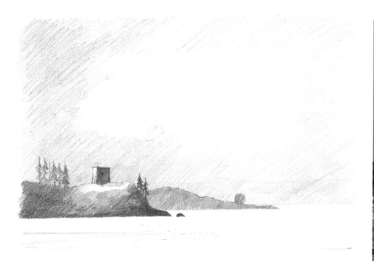

Tonal composition: *As a further aid to the painting I have created a tonal composition, working from both the photograph and the previous line drawing.*

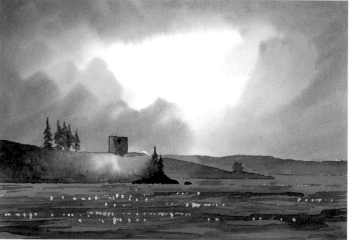

Painting: *When painting the scene I used my tonal drawing for the main reference and the photograph for the colours and details. The main aim of composition is to retain the originality of the scene but at the same time to try and improve it aesthetically.*

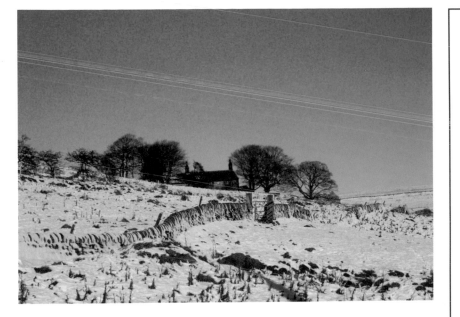

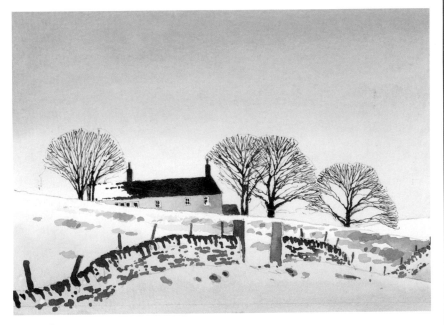

Cropping is a great way of closing in on a subject and singling out an interesting scene. Either use a simple crop tool in a photo editing programme on your computer or a couple of pieces of of L-shaped card to isolate details from a photograph. Here, the scene remains in proportion but the position and scale of the building has been improved by cropping off the extremities of the picture.

photos and computers

Composition works in a cycle: the more you work at it, the more you can automatically compose when you are out looking for subjects to paint, and this simplifies the amount of work you eventually have to do in the studio.

When you are taking photos, try to compose the scene as best you can in the viewfinder. If the sunlight is intermittent, wait a few extra minutes until it reappears, as strong sunlight can make all the difference in a landscape. Remember, one good photo is worth more than a film full of mediocre ones. Digital cameras are capable of capturing hundreds of pictures without all the processing costs, which means that you don't have to be selective with the number of photographs you take.

If you make sketches these don't have to be artistic masterpieces; they are just your own visual notes, and so long as you can understand them, that's fine. If you are working from a poor photograph or there is just too much in the scene, you may consider using atmosphere as an aid to simplification – for example, rain and mist can be used very effectively in order to lose large parts of a landscape.

More and more of my students are now turning to computer-assisted composition. By using a picture-editing program the original photograph can be altered and composed on screen, then printed and worked from. Some people even work directly from a laptop computer conveniently placed in their work area. It is inevitable that as time goes by this method of working will become the norm, and, as with anything new, there are positive and negative implications. On the one hand, the on-screen photo quality, depth and realism from which to work have never been so good. On the other, traditional skills of controlling pencil on paper may become neglected, along with the benefits and accrued skills connected with them.

landscape features

In the previous pages I have described the individual techniques and subjects associated with watercolour painting. This is fundamental groundwork, and it is thus worth referring to this information over time as you progress with your work. Now let's put these techniques into the context of painting landscapes.

general tips for painting landscapes

The conventional way of painting a landscape is to start with the sky and gradually work towards the foreground: for instance, sky, background, mid-ground and finishing off in the foreground. This way of working ensures that you progress down the paper from top to bottom, but it is by no means a strict rule, and in any case your way of working will be subjective to the scene you are painting. Whatever way you tackle your paintings, aim to paint big, loose colour washes first, followed by any shadows or areas of shade, and finish by painting the fine details last.

It is often a good idea to break a landscape down into its component parts, such as trees, skies, water, rocks and so on, and then practise these individual features on their own before putting them together in a painting. Concentrating on single elements, such as trees, for a few hours can be far more beneficial to your overall improvement than struggling your way through several landscapes crammed with many different features.

sky and atmosphere

Sky usually has an important role in the composition of a landscape painting and also reflects the general atmosphere and mood of a scene. It is worth experimenting with painting different skies along with their atmospheric effects, as this will help to generate variety and spontaneity in your work. Use a ratio of one-third land to two-thirds sky for atmospheric paintings, and keep the content of the painting simple.

Snowdon from the Zig Zags, *33 x 50.8cm (13 x 20in)*
This mountain subject lends itself entirely to strong atmosphere and mood. Although I collected the subject matter on a bright, sunny day, I felt compelled to alter the sky and infuse movement, mystery and drama into the scene. Working this way is incredibly exciting, as you are not only painting what you see on the outside, but you are also painting from within. Inspiration is a very powerful force – but to use it to your advantage you need to accrue the necessary painting skills and this is where practice is all-important.

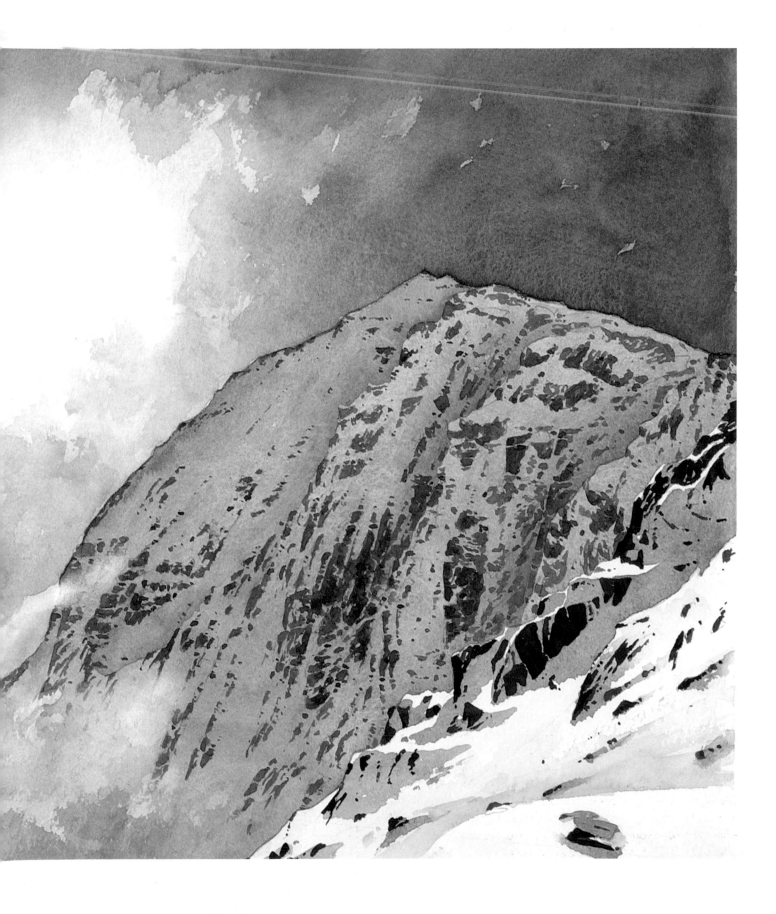

soft backgrounds

Quite often when a background is a little over-busy and is distracting the eye, rather than supporting the focal point, it may be necessary to soften it so that it acts more like a background than a focal point. Here are some suggestions that I often use, but be aware that the success of these techniques will depend on how staining your colours are and the type of paper that you are using.

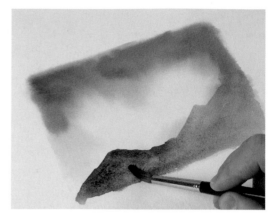

In this exercise the sky is painted in first and allowed to dry. The hills are then painted wet-on-dry and softened into the sky area at one end using clean water.

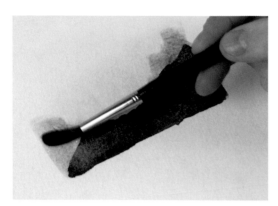

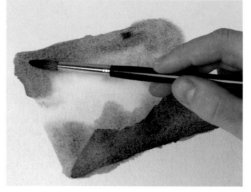

Here, the background hills are painted first and allowed to dry. The entire area is then wetted with clean water and a wet-into-wet wash is brushed in, softening the background hills and infusing a realistic atmospheric effect.

Here, a wet-into-wet technique is used to suggest an atmospheric sky. While this is still wet a much stronger tone is used to suggest the soft hill shapes in the wet wash.

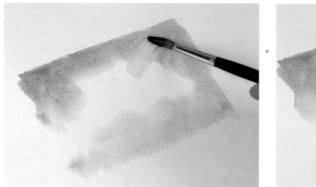

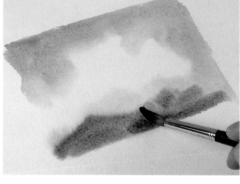

rain

Rain has an evocative charm and can be used to simplify the landscape by bringing sheets of it over distant hills or areas of general distraction. Use a free, flowing wet-into-wet technique with a steep board angle to achieve fingers of rain coming down.

On a rainy day colours usually become muted due to the low light conditions, and everything takes on a grey hue. Use greys for the sky and mix these with the ground colours. You can really exaggerate the atmosphere of a rainy day by simplifying the colour scheme to just two colours, for example French ultramarine and light red, as I have done here.

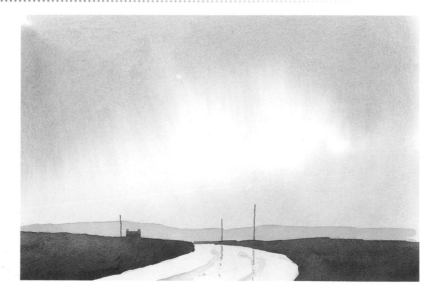

clouds

There are numerous ways of creating clouds and cloud shapes, the most expressive way being that of using a scumbling technique (see brushstrokes, page 16). Use the brush on its side and loosely scrub in the shapes, leaving bits of the white paper as highlights.

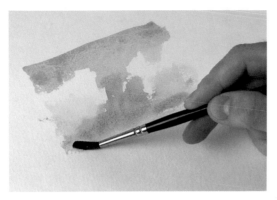

Scumbling with very diluted, fluid washes produces both sky and cloud shapes.

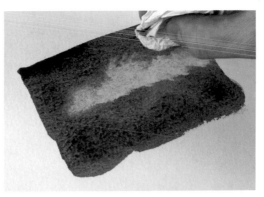

The whole of the paper is covered with a strong wash, and tissue is used to pull off pigment.

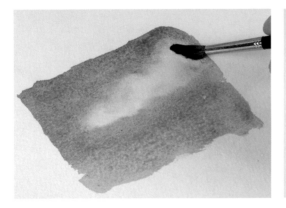

Smaller, more delicate areas of cloud can be pulled out by using a damp brush to leach the pigment off the paper.

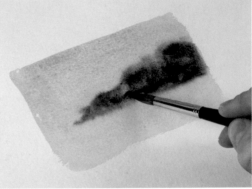

Ominous storm clouds can be created by dropping a dark wash on to a still-wet (not damp) first layer of colour.

sunsets and sunrises

The colours that are predominant at these times of day are always a joy to see. Use a fluid mix of warm colours – yellows and reds – to start with, and once these are dry, paint the cooler cloud shapes over the top. The beauty of working in this way is that you can achieve a crisp, clean finish to the sky and the warm colours will glow through the cooler clouds, creating a really natural and atmospheric appearance.

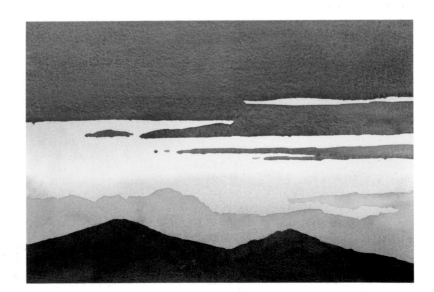

lighting, shadow mixing and contrast

Along with atmosphere, you may wish to use or capture certain light effects in the landscape. With the right approach to mixing the colours you should be able to create satisfactory results pretty easily (see colours, page 20).

Look for the lightest parts first, followed by the darkest areas, and then calculate the strengths of the mid-tones. Reserve any light parts from the outset, using masking fluid if necessary. To make areas appear lighter, use darker tones elsewhere in the painting in order to increase the contrast (see tones, page 24).

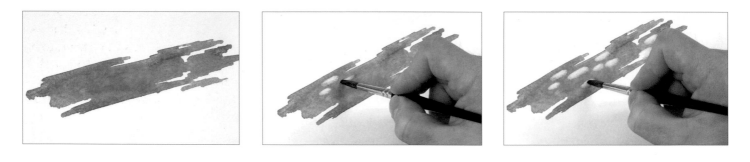

A Track Through the Woods, 22.9 x 33cm (9 x 13in)
To create dappled areas of sunlight amid shadows, use a damp brush to pull out small patches of pigment from a dry wash; be careful not to overdo this or make it too regular.

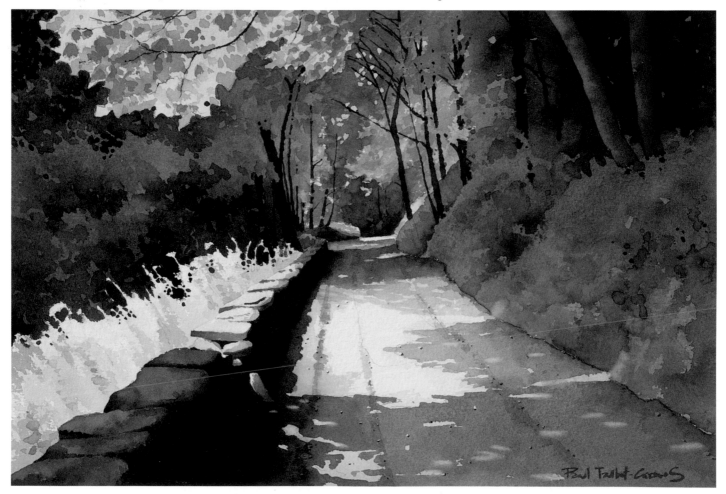

buildings, rocks, walls and textures

When you look closely at rocks or at the stone walls of buildings, you will notice that they are made up of many different colours, tones and textures. To capture these effects, use loosely mixed colours on the paper as an initial overall colour wash. When the area has dried, introduce some texture on to the area by scumbling (see brushstrokes, page 16) over the top with a slightly darker or shadow colour. Finally, if any detailing is required, this should be added after the colour, shadow and texture washes have dried.

The general process to follow when creating textures on buildings is to put in the varied colours and allow them to dry (left), then with a scumbling technique, scrub over the area gently using a slightly shadowed colour of the original wash. Finally, with more of the shadow colour, you can add details on top.

The same process can be applied to rocks and stones – colours first, followed by shadows then textures, and finishing off the process with darks and details.

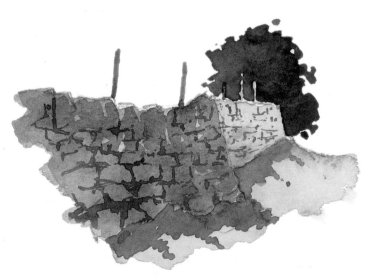

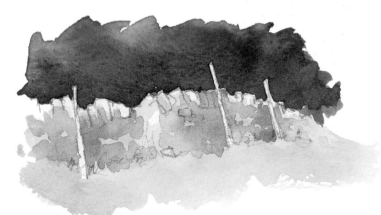

In areas with more detail, use the full process. Note that the wall has cast shadow on it. This must be painted before the darker, fine linework, otherwise the detail will bleed.

In areas with less detail, for example in the distance, it is possible to suggest stonework by applying just the colour and texture stages.

foregrounds and lead-ins

It is easy to become confused with the concept of a foreground because this is the nearest part of the painting to the viewpoint. A common mistake is to fill this area with as much intricate detail as possible, which can distract the viewer's attention away from the focal point. I generally try to simplify the foreground as much as I can to avoid over-working the painting.

There are some very simple ways of creating subtle interest, such as using loosely mixed and varied colour, darker tones or even cast shadows. The use of scumbling or drybrush (see brush-strokes, page 16) can be very effective to suggest heavily textured areas without having to depict every single pebble and stone.

If you are painting grass don't try to paint every blade or you will be there forever. Paint an initial col-our wash first and allow it to dry before working on top of it. You may wish to use one of the following techniques.

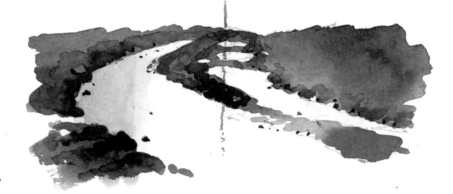

If you have thought out the composition of a painting (see composition, page 28) from the outset, you will probably have used a lead-in to the scene, which will usually cut through the foreground and reduce the amount of potential detail. A lead-in can be anything relevant to the scene, such as a stream, path, road and so on.

From left to right:
Negative painting – put in the darker area behind some lighter grass, then immediately soften it away with clean water.

Positive painting – use some stronger paint to suggest a few grasses and then soften the bottom of it away with clear water.

Scumbling – textured ground or larger areas of grass can be suggested with the application of the scumbling technique.

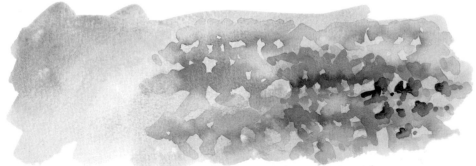

From left to right: When dealing with rough or stony ground I usually paint in an overall colour wash and follow this with a couple of layers of stippling, allowing drying between each layer and making sure that plenty of the underwash shows through in angular chinks. I then finish the area by painting darker shadows on one side of the lighter shapes.

trees
winter trees

When painting winter trees, look carefully at the main structure of the tree, especially at how the branches taper in a very angular fashion. Also pay particular attention to the canopy where the twigs finish, leaving a neat, cropped appearance. To avoid making your tree look like a cardboard cutout, make sure you include a few branches projecting at angles other than 90° to the trunk. Work outwards from the trunk and use a combination of brushes, for example, a No. 6 round for the main trunk and branches, followed by a No. 1 rigger for the gradually tapering thinner branches and twigs (see Brushstrokes, page 17).

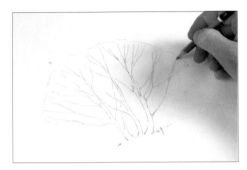

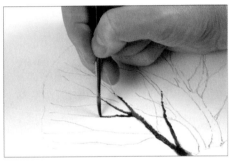

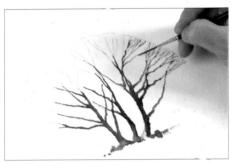

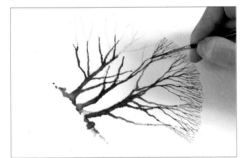

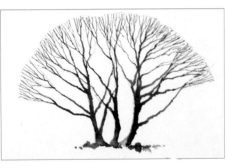

From the initial drawing – note the curve of the top of the tree – work from the bottom up, starting with the thickest trunks and looking for variations in colour and tone (above and left). As you go up and away from the trunks, use lighter strokes and less pressure. I used a No.1 rigger throughout for this study.

A simple scumbling technique can be used for background winter trees (right), and this can be enhanced further by quickly pulling out a few fine twigs here and there with a rigger while the scumbling stroke is wet.

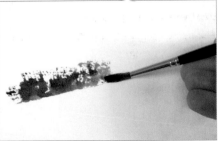

For soft single background trees use the wet-into-wet technique (right): draw into a wet wash at the optimum time, using a rigger and very dry paint.

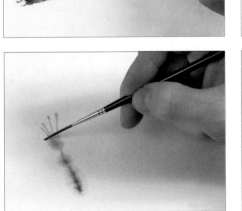

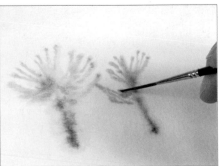

summer trees

When painting a summer tree, aim for the main shape with the initial colour wash, and use varied colour as opposed to one flat green wash: French ultramarine mixed with a bright lemon yellow, for instance, will create a good natural colour that you can paint loosely on to the paper. Mix it with a complementary colour, such as light red, to create the shadow parts (see colour mixing, page 19). I often use sap green for lit areas of foliage and a varied mixture of Hooker's green and Payne's grey for darker shadow areas.

Use a combination of the scumbling brushstroke and the stippling brushstroke to create the ragged broken edge of a tree canopy. I find that stippling with an old, blunt round brush is very effective at suggesting the scattering of leaves seen around the outline of the tree. As with winter trees, background summer trees can be suggested with simple techniques such as scumbling and wet-into-wet.

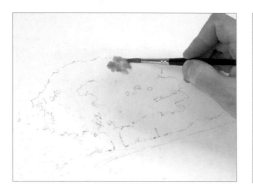
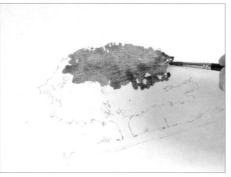
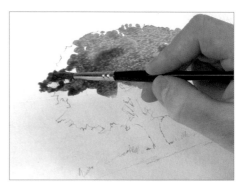
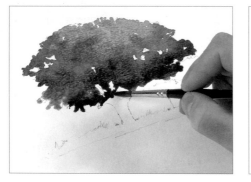
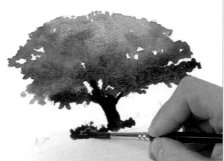
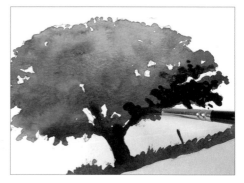

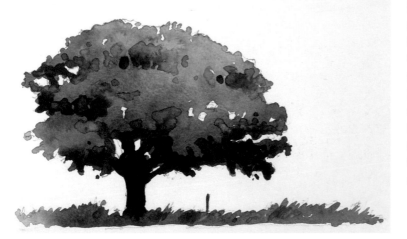

For a summer tree, start with the lightest part, the leaves at the top, in sap green, then as you go down, add some French ultramarine to the wash, working wet-into-wet. Where the leaves are in shadow lower down, make the mix stronger and darker with Payne's grey; leave gaps in the foliage and look for lighter areas even within the dark ones. The trunk and main branches are silhouetted, so use Payne's grey on its own here. Soften where the lighter and darker areas meet with clean water; then use a mix of the three colours together for the areas beneath the tree, which are in shadow.

For soft background trees in full leaf, you can use either of two techniques. With wet-into-wet (top layer below) start by wetting the paper with clean water and allowing it to dry a little, then drop in a fluid wash, building up the darker tones while the first wash is still wet. When it has dried some more, add details. Working wet-on-dry (bottom layer below), scumble on the wash, looking for variations in tone and building up the shapes and forms with different brush pressures (see brushstrokes, page 16).

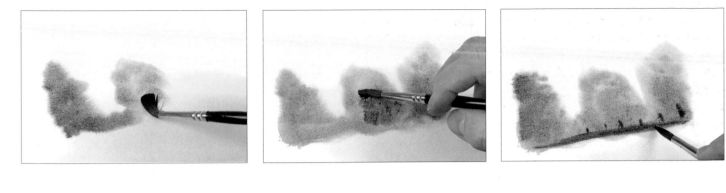

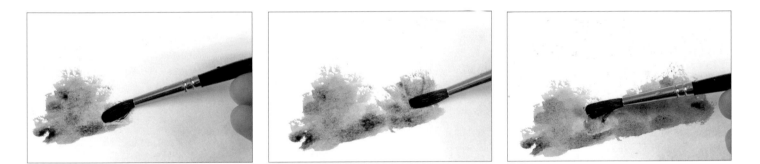

Q&A

'I keep getting a false looking hard line around the edge of my washes'

If your washes form hard lines either all of the way around an object (as illustrated here) or where two separate washes meet, then there are a couple of remedies to follow. If your wash is outlined, like mine is here, then this is because either too much paint has been applied allowing it to puddle, or you have added extra paint to the entire wash whilst it is in the process of settling on the paper. In essence, this will form a large runback over the whole wash area. Either mop up excess paint as you apply it or resist the temptation to add more paint to a drying wash.

If you create hard lines where two washes meet – where the sky meets the edge of a tree, for example – consider overlapping them instead of butting them together. For example, don't finish the sky wash around the tree outline, wash it over the top of it. When you paint the tree you will have a clean, crisp edge as opposed to a hard outline.

water and reflections

Reflections in water can vary in effect from still, mirror reflections to extended reflections where a slight breeze may lightly ripple the surface of the water. The angle of the viewpoint will also affect the amount of reflection that is visible, so take note of what you are working from.

Still water and gentle reflections evoke feelings of calm and always look good in a painting; and they are also relatively easy to paint. Reflections can be painted using wet-on-dry or a wet-into-wet technique, but be very careful to mirror shapes, angles, colours and tones. As a general rule, light objects should be reflected slightly darker and dark objects reflected slightly lighter. Keep reflections in a vertical format and, if this helps, lightly draw out the mirrored shapes first in pencil.

If you are mirroring shapes using a wet-into-wet technique, use less water mixed with the paint, and work with your paper flat on a table so that you can capture soft shapes.

still water

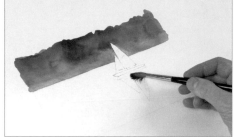
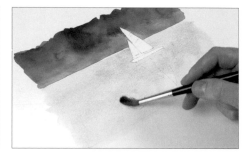
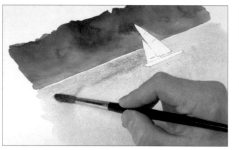
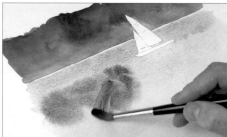

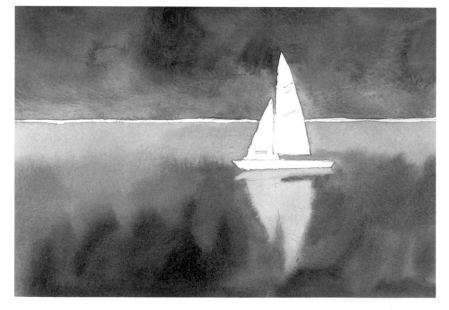

To paint reflections using the wet-into-wet technique, first paint the background trees down to the water line, leaving the sail as a negative shape, and allow to dry. Wet the whole water area with clean water, again with the exception of the boat and sail, and when this has dried a little, apply a blue wash over the water. While this is wet, add the lightest green (I used sap green), then blend this with the darker green (Hooker's green with some Payne's grey), leaving the boat's reflection as the blue first layer. Use a damp clean brush to remove any excess paint around the reflection.

rippled water

To paint reflection wet-on-dry, start as for wet-into-wet with the background trees, allowing them to dry and painting the sail as a negative shape. Paint just the reflection of the boat in the water area, and again allow this to dry before putting in the sap green as a separate layer and leaving the boat as a negative white area. When the sap green is dry, apply the darker green, working it carefully into the edges of the blue reflected area and allowing some of the lighter green to show through.

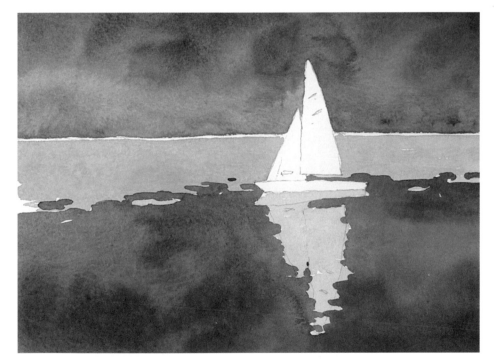

alternative textures

H ere are a few ideas for taking watercolour a step or two beyond traditional approaches. By adding certain substances to washes, it is possible to create a whole variety of effects and textures in your work.

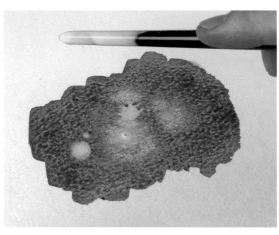

Masking fluid is mostly used for reserving white or light areas of a painting, but try dropping it into a wet wash and allowing everything to dry before peeling it off. This is great for creating the effects of moss and lichen on a wall.

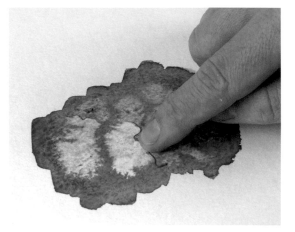

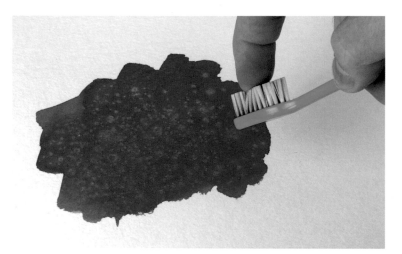

Pure alcohol or surgical spirit creates a lovely speckled texture, especially when it is spattered on to a wet wash with an old toothbrush.

Pressing **thin polythene or cellophane**, such as cling film, into a wash creates interesting textures and patterns. Lay a medium-strength wash, and while this is still wet place a screwed-up piece of thin cellophane carefully over the area and put a weight, such as a large book, on top of it. Allow extra time for the wash to dry, due to this area being covered with plastic. This effect works best on hot-pressed or cartridge paper.

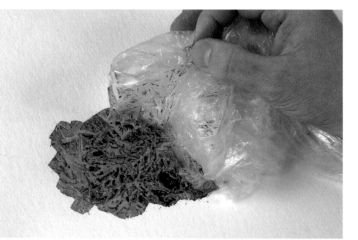

Another very effective way of adding textures to your work is to use an old **toothbrush** to spatter paint on. Pick up paint using the toothbrush, then draw your thumb or a blade across the bristles, firing specks of paint on to the required area. You may need to mask off other areas of your painting before using this technique; this can be done by laying newspapers over the parts that you don't wish to cover.

Alternatively, hold the loaded toothbrush upside down and tap it against your other hand, allowing blobs of paint to spatter on to the paper. This is an effective way of creating snowflakes on a painting when used with Chinese white or white gouache.

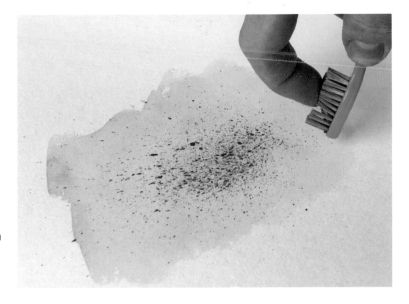

Salt crystals create fantastic starry textures when sprinkled on to a wet wash. Allow the whole thing to dry before you brush off the crystals.

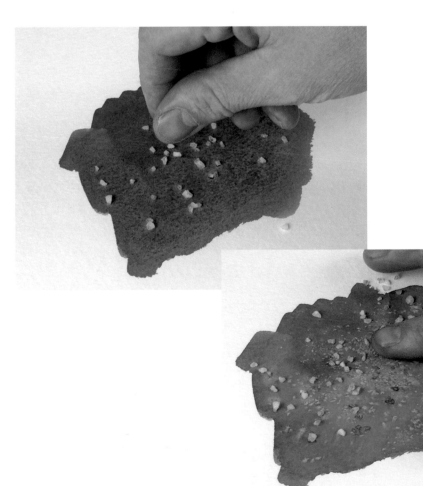

troubleshooting

You will inevitably come up against a number of problems with your painting, some more than others, especially during your early years of handling watercolour. Here are some of the more common problem areas you are likely to encounter as you progress with your work.

Q&A

'I cannot achieve soft wet-into-wet effects. Instead, I end up with hard edges, runbacks and streaky results.'

If your paint is not flowing as it should, it is likely that your paper is drying before you begin. Wet the paper and let the water soak in by leaving the board flat down. Rewet the paper and brush the water around in all directions using a big brush until you end up with a satin finish to the sheen. Try working fairly quickly with the wash, and keep checking the sheen against the light. As soon as it begins to take on a matt appearance, stop applying paint.

Q&A

'My paper keeps cockling when I wet it.'

Either select a heavier weight of paper – around 640gsm (300lb) – or stretch lighter weights. If the gummed tape fails while drying, the paper will still cockle: cut it off the board and run it through the stretching process again.

Q&A

'My washes are blighted with hard-edged runbacks.'

Runbacks, also known as cabbage marks, cauliflowers and blooms, occur when one area of a wash dries off more quickly than an adjacent one. This can be due to working too slowly, having varying amounts of water on your paper, or the paint drying too quickly: the wet area of the paper becomes drawn into the drier area and leaves a hard-edged, cauliflower-shaped mark in the paint. Although they are generally looked upon as errors, there are certain times when runbacks actually enhance landscape features, such as in trees, where the bloom can suggest foliage and textures.

To avoid runbacks in your paintings, make sure that the wash you are applying is evenly wet and that the leading edge of the wash is fluid as opposed to dry (see flat wash, page 13). Never apply paint that is wetter than the surface of the paper, as this will definitely create a runback. The most common error here is when the artist attempts to correct a drying wash with a brush loaded with paint. If you can't resist going back into a drying wash, remove most of the paint from the brush first.

Q&A

'I repeatedly create streaky, dry marks within my washes.'

This is a very common problem. A streaky or 'ploughed field' effect can be pinpointed to a number of reasons, the most common being that you are not using enough paint on the brush. When you are applying a wash, make sure that there is a reservoir of paint accumulating at the bottom or leading edge. If there isn't, you need to increase the amount of paint that you load into the brush. If this doesn't work, try increasing the size of the brush, making sure that it is fully loaded when applying the paint to the paper.

Other reasons for streaky washes can include working too slowly with the wash, using cheap or inappropriate paper, or working in a warm or hot environment where the paint dries too quickly.

Q&A

'I continually create fine lines in my drybrush technique.'

If you are creating lines in your drybrush work, this is because the point of the brush is coming into contact with the paper. Make sure you have the brush flat to the paper and drag the belly of the brush across the surface, keeping the point off. At the end of the stroke, lift the brush vertically in the same position that you held it on the paper. Don't twist the brush upwards like a plane on take-off, or you will leave a line or a blob of paint.

Drybrush is easiest to achieve when a large, natural-hair round brush is used in conjunction with rough-surface paper. Try increasing the size of your brush, especially if you are using a synthetic one, as this tends to have a shallow belly and doesn't generally produce the best results.

Q&A

'I lose any form of shape when I'm painting wet-into-wet.'

Wet-into-wet requires optimum timing with washes and paint applications. Make sure your paper isn't too wet by checking the sheen against the light – any areas of standing water or puddling will disperse any paint that you add, and you will lose shapes and definitions completely.

When adding the paint, make sure that you are removing some of it from the brush first. If you cannot see your effect, your paint is probably too pale, so increase the strength of the paint mix. Paint added to wet paper needs to be much stronger than normal, but if your shapes are still dispersing, try using a slightly smaller brush, as this will unload less paint. By keeping your board at a shallow angle, or even flat on the table, you will increase the chances of shapes remaining where you put them on the paper.

Q&A

'My painting looks washed out, and I can't seem to make the lights any lighter.'

If a painting lacks depth, this is usually due to the lack of tones, especially the dark tones. By adding the darkest tone of the scale, you automatically create reference to the lighter ones, and they then appear lighter in turn.

Tonal work is extremely important, and I suggest you recap on the points within the tonal section of this book (see tone, page 24). To create stronger tones, you must use more paint than water in your mixes. Squeeze out a 25mm (1in) diameter of paint into your palette, which will encourage you to use it.

Q&A

'My greens look false, even though I have used the greens that are in my paint set.'

Tube or pan greens are base colours that should be mixed with other colours. Try mixing them with yellows, blues, violets or reds to create more natural-looking greens. Payne's grey is great for neutralizing the harshness of a paint-set green.

Q&A

'I tried to remove some Prussian blue, but it won't come off. Is it possible to correct my painting?'

The success of a correction is dependent on a number of circumstances, in particular the properties of the paper you have used and the pigments involved. Some papers absorb paint well into their fibres, resulting in a limited amount of paint removal, while others release paint very easily. As for paint, some colours are very staining, such as Prussian blue, and others wash off completely.

If you are unsure about a colour, test it first on a piece of paper before you use it. If the area that you intend to correct will not wash off sufficiently, you may wish to consider making a slight alteration to your painting: an overworked sheep or cow could be turned into a boulder, for instance, or if the mistake is in your sky area, you may want to modify the atmosphere by making the whole or part of the sky darker.

Q&A

'I am trying to mix three colours together to create a dark green, but I can only achieve a muddy brown colour.'

If you mix three colours together at any one time, you will definitely get into difficulties. Only ever mix two at a time, for instance a blue and a yellow to create a new colour – green – then add some red to the green you have just mixed. So even though you are dealing with three colours, you are only mixing two at any one time.

Q&A

'I want to redo a large part of my painting.'

Before you redo any parts of your painting, you need to remove the existing paint. Sponging off paint is a good way of removing blemishes or sections of the painting that you are not happy with. Make sure the painting is completely dry, then wet down the area with clean water and let it soak in for a short while. Adding gum arabic to the water increases the chances of removing the paint.

Use a dampened sponge to gently rub and dab at the section, soaking up any excess with tissue. Once the area has dried, repaint any colour washes and continue with the painting.

Q&A

'I have finished my picture, but I painted over some areas that I wanted to leave white.'

If you need to reinstate a highlight or white area in a painting, there are a couple of ways around this. You can scratch off the surface paint with a blade in order to get back to the white paper, but this is rather a drastic measure and should only be done at the very end of the painting. Better still, use white paint, such as Chinese white or white gouache, to reinstate areas of white in a watercolour. Use the paint thickly, and add very little water.

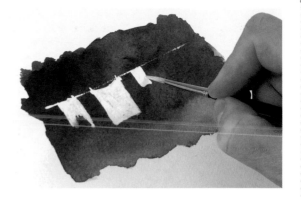

Q&A

'I spent hours drawing out my scene, but now my painting has gone wrong. Can I start again on the same paper?'

Paintings have a habit of going wrong, especially after you have spent a lot of time on the drawing. In cases like this, it is possible to remove the majority of the paint and still retain some of the pencil work so that you can have another go at it without having to draw it out again.

Get the painting to a sink or bath and run it under the tap. Using a soft sponge, gently coax the paint off the paper while the water is running over it. Once the painting is back to white paper (or as near as), mop up all the excess water with tissues and allow it to dry thoroughly before restarting the painting process.

You may need to reinstate some of the pencil work before you begin to paint. If your pencil lines have totally disappeared, you need to use more pressure on the pencil; for best results, use a 2B or 3B grade. As a last resort, you can always turn your paper over and paint on the back.

Q&A

'I want to remove only a small area of paint.'

For removing smaller areas of paint, I find a 6mm (¼in) flat synthetic brush works well. Wet the area first before gently scrubbing with the brush, and use tissue to mop up the loosened colour. Synthetic brushes tend to be a little stiffer than sables and don't cost as much to replace when they're worn out.

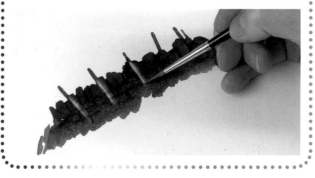

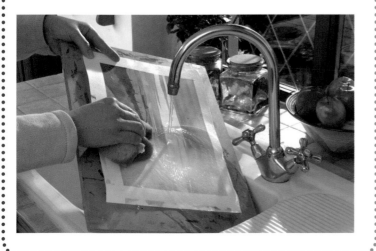

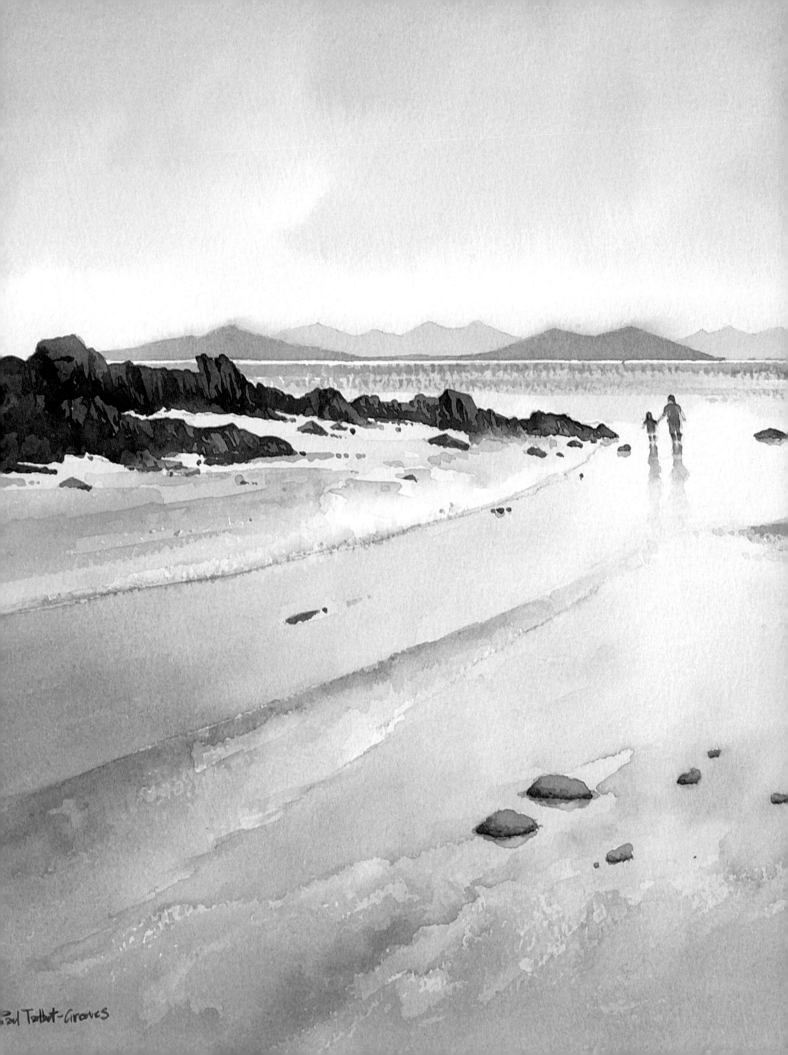

Paul Talbot-Groves

basic projects

sunset silhouette

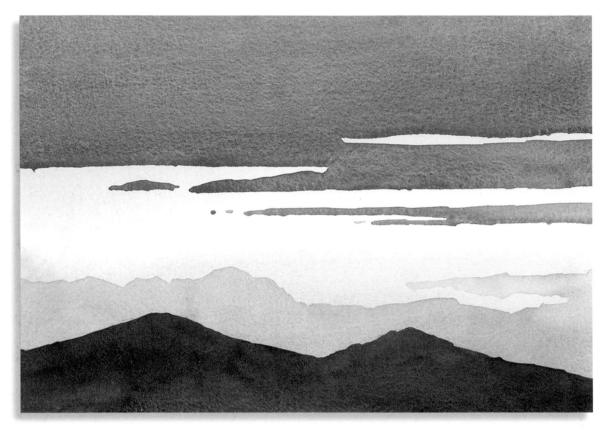

T his first project utilizes simple washes and results in
maximum visual impact due to the contrast between the
darker foreground and the lighter parts of the sky; it is also
an excellent exercise for practising basic washes and brush
control. Try to concentrate on using fluid washes by constantly
recharging your brush with paint, and really aim to gain careful
control of the brush, especially when painting the delicate
cloud edges.

you will need

| lemon yellow | cadmium red | French ultramarine | burnt sienna |

brushes & other equipment:
25mm (1in) flat and No. 8 round •
Bockingford NOT 410gsm (200lb) paper

step one
Make up a very fluid wash of lemon yellow, and cover the whole
picture with this, using a large flat wash brush. While this is still
wet, paint a wash of diluted cadmium red across the bottom
third of the paper, across both the land and the base of the sky.

step two

While the first wash is stll wet, paint the top third of the picture with the cadmium red – this is a base colour that will add to the effect of subsequent washes. Use clean water to blend the top of the bottom red wash and the bottom of the top red one, and allow everything to dry completely.

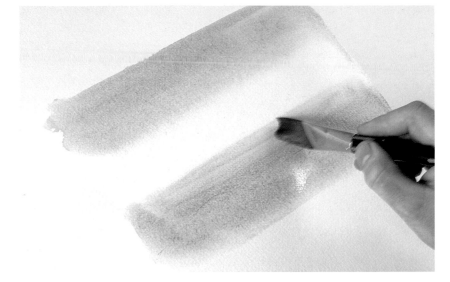

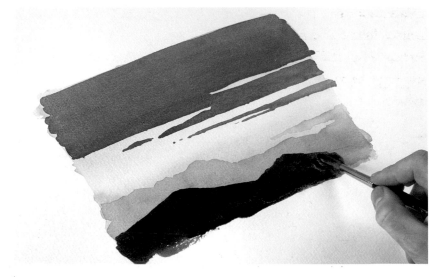

tip

Allow the yellow and red washes to mingle on the palette, and blend them on the paper.

step three

Make up a watery mix of French ultramarine and cadmium red, and use a No. 8 brush to paint this over the red and yellow at the top of the picture, working from side to side across the paper. Leave some gaps in the background washes to suggest the clouds breaking up.

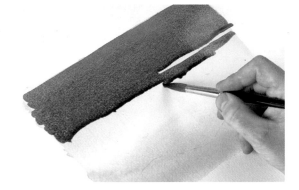

step four

With a very weak wash of the same colours, add the distant clouds above the land area, further diluting the wash with water to show recession.

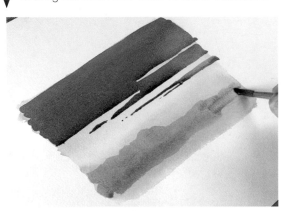

step five

When the clouds have dried, paint on a strong mix of French ultramarine and burnt sienna for the land mass, which is completely in shadow.

atmospheric lake

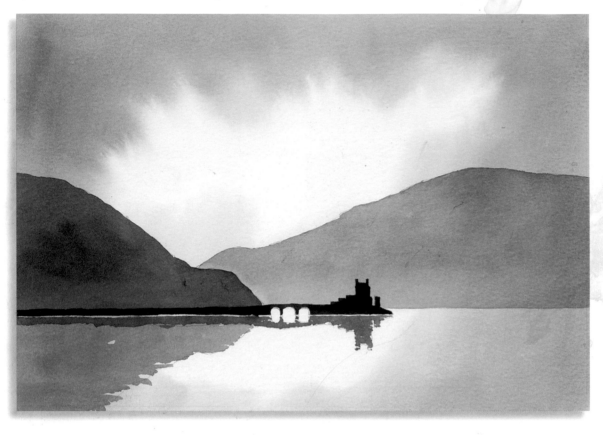

In this painting, the challenge is to make two colours look as interesting as possible. This is great practice for utilizing colour and tone to the best of their potential. Try to vary the colours as much as possible by mixing them loosely on the paper as you paint – the more variety you can create, the more natural the image will appear: lifeless, overmixed washes of colour will make your scene look as though it was cut out from flat pieces of cardboard, so bear this in mind as you paint.

you will need

Prussian blue alizarin crimson

brushes & other equipment:
Nos 12, 8 and 4 round • Bockingford NOT 410gsm (200lb) paper

▲ step one
With the outlines of the scene drawn, wet the whole picture with clean water and a No. 12 brush. To make it easy to manipulate the paint working wet-into-wet, I let the water soak in for a couple of minutes and then re-wet it all.

step two

With the same brush, mix the blue and crimson to a mid-tone with lots of water. Put this into the sky area, keeping the brush flat on the paper, then work into the lake for the reflection of the sky. While this is still wet, put on a slightly stronger mix, leaving white paper for the lightest parts. Allow to dry.

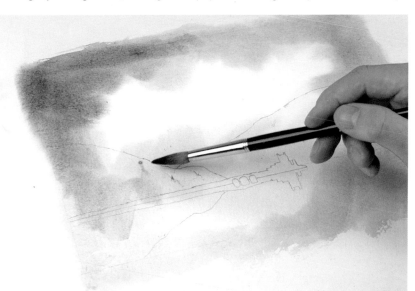

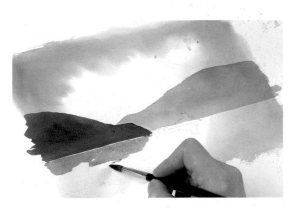

step three

Switching to a No. 8 round brush, add a bit more Prussian blue to the mix and apply this in a simple flat wash to the right-hand hill. Use the tip of the brush for where the hill meets the sky, and the side for the edge that meets the lake. Allow to dry completely.

step four

Using a slightly stronger mix, this time adding more alizarin crimson to warm it up, put in the left-hand hill, again using both the tip and the side of the brush.

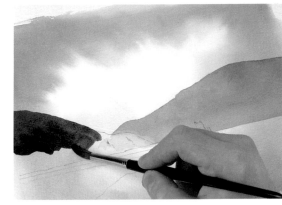

step five

Dilute this mix and add the reflection of the hill in the lake, with a line between the two. Work with a side-to-side motion, leaving some highlights. Allow to dry.

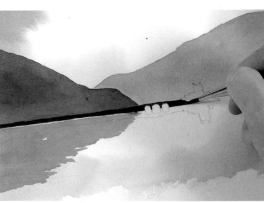

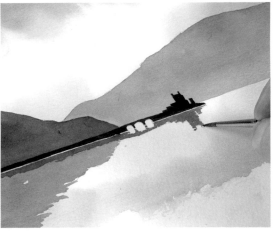

step six

With a No. 4 brush, make up a strong mix of equal proportions of blue and crimson, and add the walkway, still leaving the bottom of the pale line. Go into the arches with the brush tip and then into the castle building.

step seven

Dilute this mix and paint in the reflection of the structures in the lake, again leaving the line – the reflected shape isn't the same as the actual one, as the refraction of the water broadens and slightly distorts it.

green scene

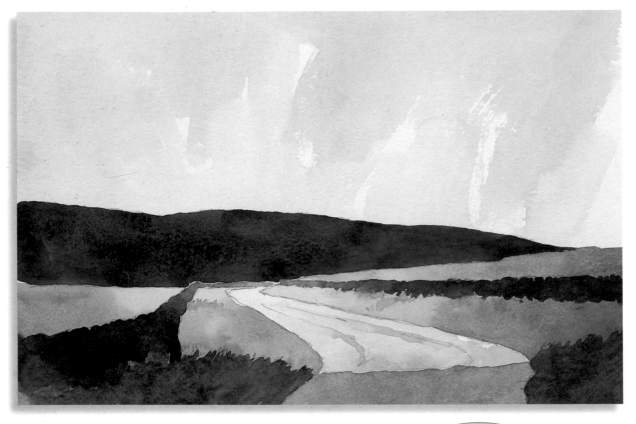

Many painters, both novice and more experienced, encounter difficulties with painting greens in landscapes. Make the task as easy as possible for yourself by using greens as base colour, adding blues to make washes cooler for distance, and yellows to make them warmer for foregrounds; this will help to create recession in your painting, as well as making your paint mixing much easier to control. This scene is simple in content, so you can concentrate on creating variety and recession via the green washes.

you will need

| sap green | Hooker's green | French ultramarine | lemon yellow | raw sienna | burnt sienna |

brushes & other equipment:
Nos 12, 8 and 6 round brushes • Bockingford NOT 410gsm (200lb) paper

▲ step one
Mix a very fluid wash of French ultramarine and use the side of a No. 12 brush to put in the sky, using rough, scumbling strokes. While wet, soften this wash with clean water leaving patches of paper uncovered for clouds. When this is dry, make a loose, cool, dark mix of Hooker's green and French ultramarine for the hills, and blend this on the paper with a No. 8 brush, letting the ultramarine show through. Allow to dry.

step two

Use the No. 8 brush to put on a mix of sap green and lemon yellow for the grass; add different amounts of green, and a bit of raw sienna, then French ultramarine towards the right-hand side of the picture – mix all the shades on the paper, not the palette. Repeat on the left-hand side.

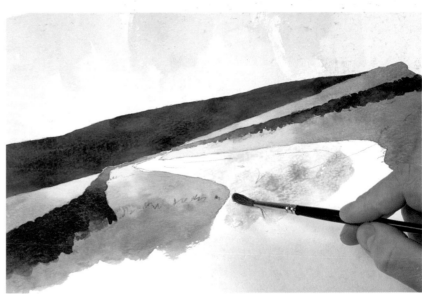

tip

Don't be afraid to experiiment with mixing colours on paper – the variety can add spice to a picture, and because the colours dry lighter, you can always go over them later.

step three

With a No. 6 round brush, put on a wash of burnt sienna and French ultramarine for the walls; add more sienna for the furthest parts and ultramarine for those nearer the cooler foreground. Occasionally soften the wall bases with clean water.

step four

For the road use a very faint wash of raw sienna with the No. 8 brush; I left the furthest part as white paper. Add some burnt sienna to the wash to warm the colour and bring it forward in the foreground.

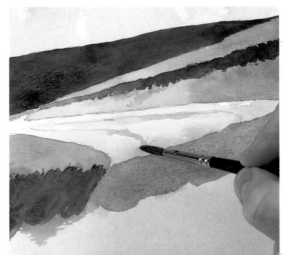

step six

Add a watery mix of ultramarine and a bit of burnt sienna for the shadow areas across the road, letting the base wash show through. Dilute this mix for the tyre tracks; soften with clean water.

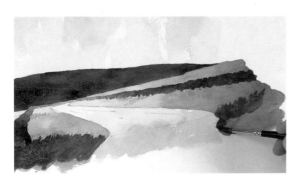

step five

Switch to the No. 6 brush to put in clumps of dark grass with a mix of sap green and ultramarine. Strengthen the mix for the immediate foreground below the walls. Allow to dry.

stone building

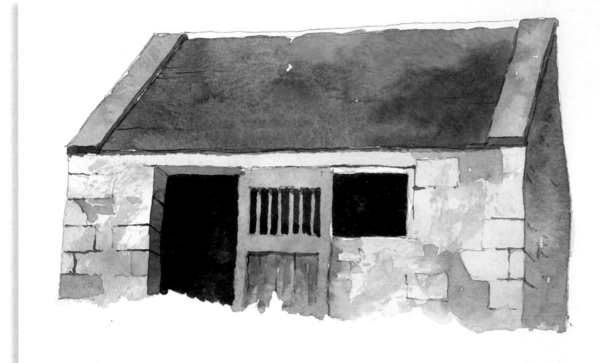

Because of their square walls and angles, buildings need to be drawn out with care initially: use a ruler if necessary to achieve straight lines, and check your perspective to make sure that receding angles look natural. This simple project uses these rudimentary techniques, as well as layering methods for achieving stone effects. Look for the variations of colour within the stonework, and brush them loosely together at the initial wash stage, as this will help to suggest about half the detail.

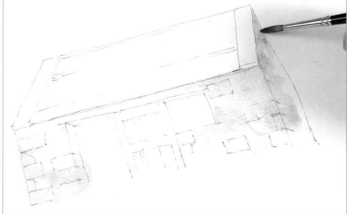

you will need

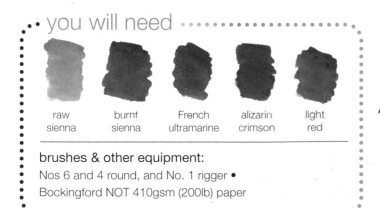

| raw sienna | burnt sienna | French ultramarine | alizarin crimson | light red |

brushes & other equipment:
Nos 6 and 4 round, and No. 1 rigger •
Bockingford NOT 410gsm (200lb) paper

▲ step one
Using a No. 6 round brush, apply very pale, watery washes of raw sienna, burnt sienna and French ultramarine for the stonework on the building, mixing the colours on the paper. To make subsequent work easier, I went round the windows and door frame, but painted over the drawn stones in the walls. Allow to dry completely.

step two

Apply a loose mix of ultramarine and burnt sienna for the side parts of the roof, then drop in a mix of raw sienna and alizarin crimson for variety and to indicate lichen.

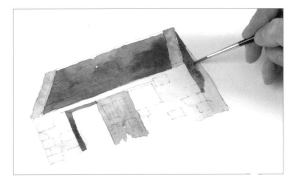

step three

Use a darker version of the ultramarine and burnt sienna mix for the door, again blending and mixing the colours on the paper.

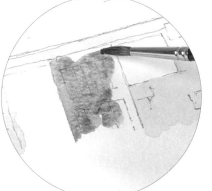

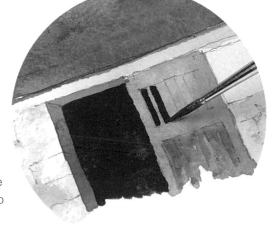

step four

Add the roof slates with a varied wash of ultramarine and light red. While this is wet, drop in the raw sienna and alizarin crimson mix to suggest more lichen. Allow to dry.

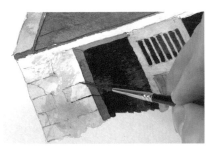

step five

With a No. 4 brush, apply a strong grey wash from ultramarine, burnt sienna and some raw sienna for the shadow areas – the door jambs and right side of the building. Scumble a very pale version of this across the main stonework.

step six

Make a very dark mix of ultramarine and burnt sienna for the interior of the window and door: use this to paint negatively into the top of the door to produce bars.

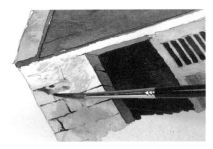

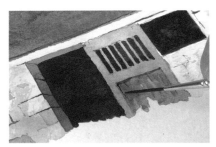

step seven

For the finishing details, I switched to a No. 1 rigger brush. Use the same dark mix to pull out some – but not all – of the mortar lines and joins on the stonework. Alternate between this and the No. 4 brush to add darker stone and areas of textured wood.

rainy road

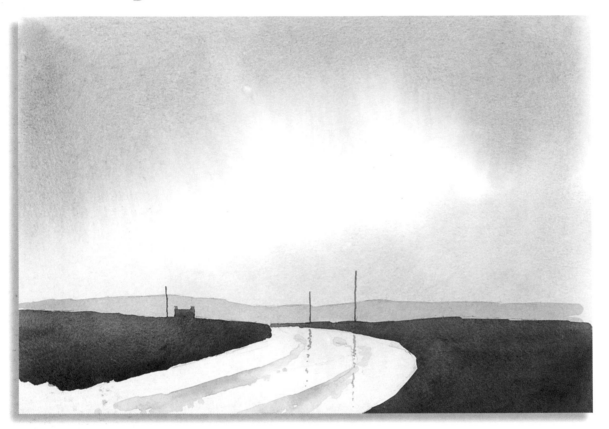

Atmospheric conditions such as rain or snow can change the appearance of a landscape entirely – with rain, the heavy sky and dull light usually cast a grey hue over the scene. This project picks up on the light effect and exaggerates it to such an extent that only two colours are used; this is a good technique for overstating the mood or feeling within an atmospheric landscape. Concentrate on using flowing wet-into-wet washes at the start, and aim to keep the road silvery and reflective; including some reflections on the road helps to emphasize the feel of rain within the scene.

•• you will need ••••••••••••••••••

French ultramarine light red

brushes & other equipment:
25mm (1in) flat wash, No. 8 round and No. 1 rigger •
Bockingford NOT 410gsm (200lb) paper

▲ step one
First mix a large wash of diluted French ultramarine and light red, then soak the paper in clean water, as described on page 14, using a large flat brush. Working quickly, apply the wash across the top and middle of the picture for the rainclouds. Tip the paper towards you so that the wash can run down a little, to give the impression of rain.

step two

While the paper is still wet, add a very diluted version of the mix across the foreground, making sure to leave the paper white for the pale sky and the sweep of the road. Don't be too concerned about the exact placement, however – this is an atmospheric picture above all else. Allow to dry.

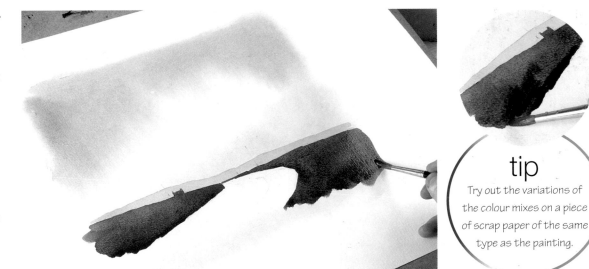

step three

Make up a slightly stronger, cool version of the mix, and use a No. 8 brush to add the furthest line of hills; this is quite a way away, so needs to be pale to provide a sense of recession. Allow to dry thoroughly.

step four

Make a very dark mix with a little more red in it – this warmer colour will help to bring the fields at the side of the road closer to the eye. Paint this on, and while it is still wet, add an even darker version towards the bottom of the paper.

tip

Try out the variations of the colour mixes on a piece of scrap paper of the same type as the painting.

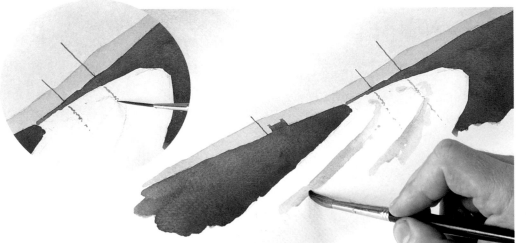

step five

Switch to a No. 1 rigger to add a medium-toned wash for the poles, and dilute this mix a little for the reflections in the road, which should be broken lines due to the rainy surface. To finish, use the No. 8 brush to add a very watery wash for the tyre tracks in the road.

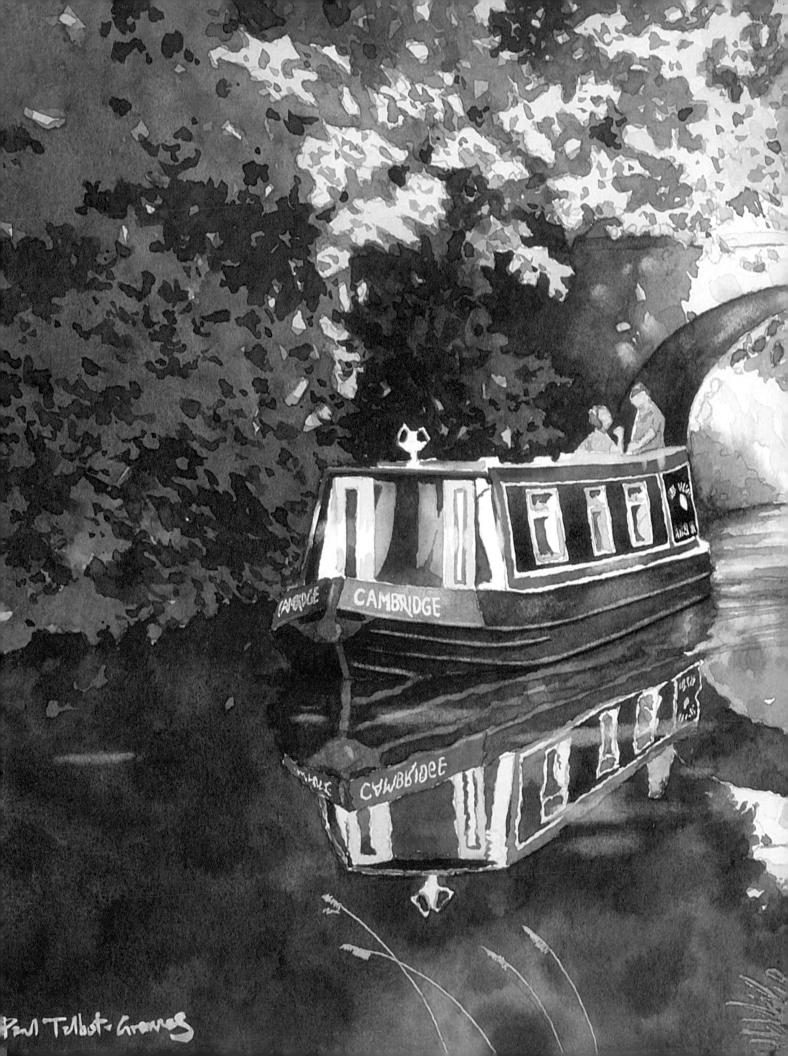

Paul Talbot-Greaves

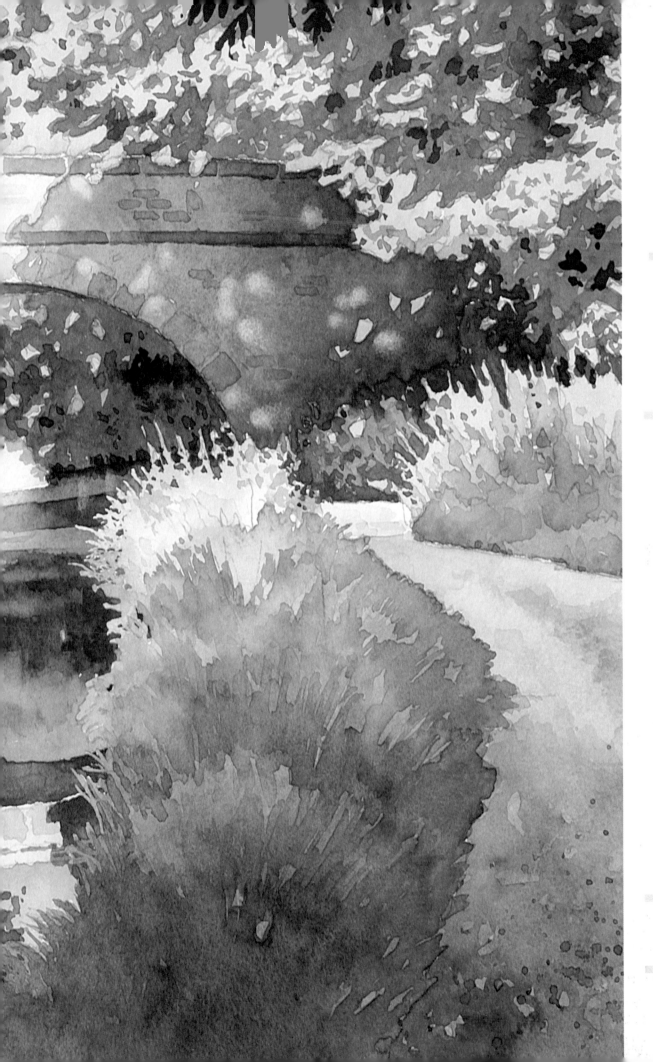

forest path

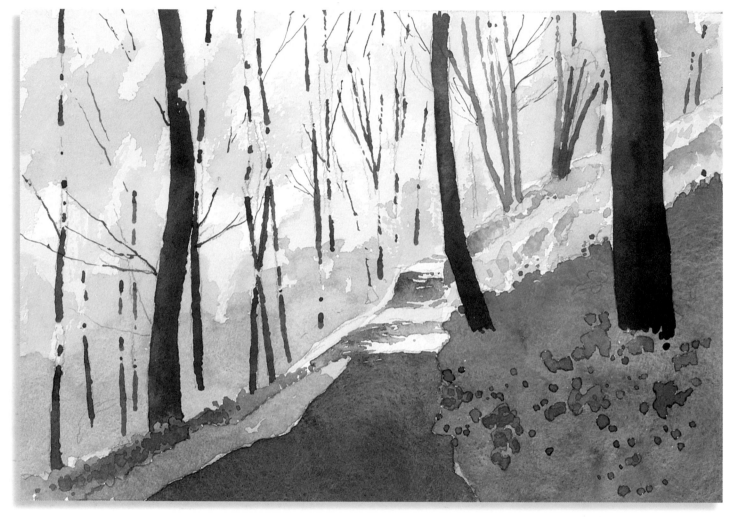

This scene attracted my attention while out walking in my local woods one spring – the track provides an excellent lead-in to the picture, and the wild bluebells and translucent foliage add a wonderful sense of colour and light. When you notice attractive elements such as these, it is important that you locate some darker tones to balance off, and contrast with the light ones; in this particular painting, the darker tree trunks and path add an invaluable sense of balance to the lighter parts of the picture.

you will need

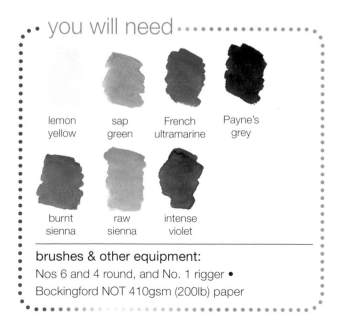

lemon yellow	sap green	French ultramarine	Payne's grey

burnt sienna	raw sienna	intense violet

brushes & other equipment:
Nos 6 and 4 round, and No. 1 rigger •
Bockingford NOT 410gsm (200lb) paper

step one

Use masking fluid and an old brush to paint the bluebell flowers. Allow the fluid to dry.

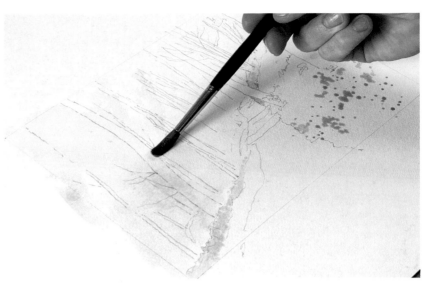

step two

Make a mix of lemon yellow with some sap green, and use a No. 6 brush to apply this for the spring leaves. Make sure to leave white paper for the sky.

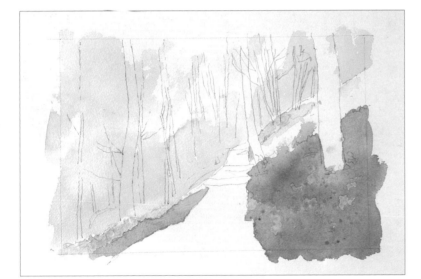

step three

Mix French ultramarine and sap green, and apply this with a scumbling technique for the initial colour base of the grass; mix the colours on the paper to get a varied effect, and treat the tree trunk on the right as a negative shape, painting around it.

step four

With the first leaf wash dry, use a darker green and yellow mix for the top part, and a mix of ul-tramarine and sap green to darken the lower part; leave some initial wash to show through.

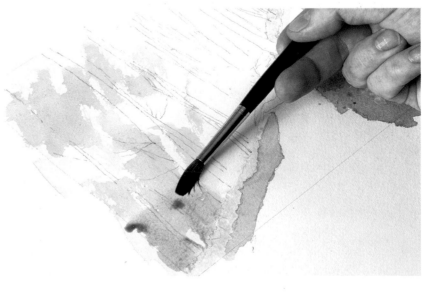

step five

Darken the shadowed
foreground grass with
a stronger mix of French
ultramarine and sap
green. Vary the strength
of the washes, and
remember to leave
part of the initial wash
showing through.

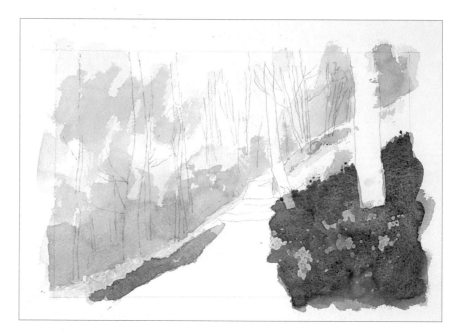

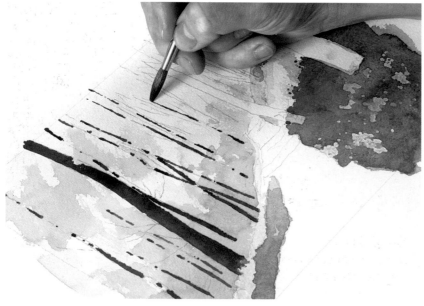

step six

Make up a strong mix of Payne's grey and burnt
sienna, and alternate between Nos 6 and 4 brushes
to paint the solid shapes of the trees, making those
on the right a little darker. Use a lost-and-found
technique to continue the lines where they are
broken up by the foliage.

step seven

Switch to a No. 1 rigger for the smallest twigs and branches. Again, look for broken lines, and vary the pressure on the brush to give varied widths.

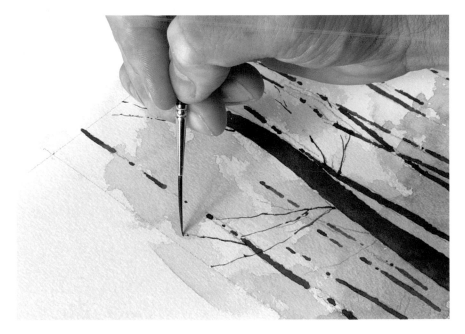

step eight

With the No. 6 brush, paint the path using raw sienna; add some burnt sienna to darken areas near the foreground. Allow this to dry, then use a clean finger to remove the masking fluid – blow off the rubbed bits of dry fluid before continuing.

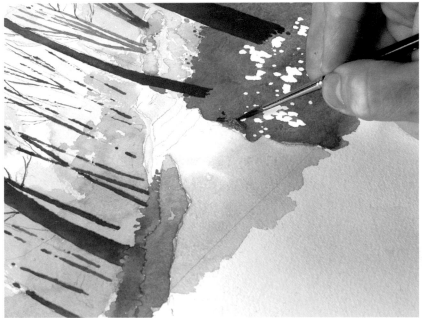

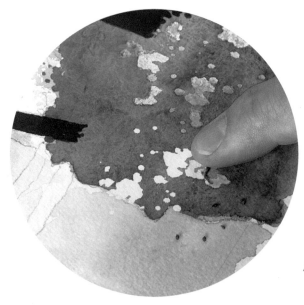

step nine

Make up a mix of French ultramarine and intense violet, and start to paint the bluebells with the No. 4 brush, making a clump on the left.

step ten

Where the bluebells are paler in the light, dilute the mix. Try to get the mix purely on the white paper, but don't worry if you go a little bit over on to the grass; blot off or pick up excess paint – you're aiming to capture the essence of the scene, not each individual flower.

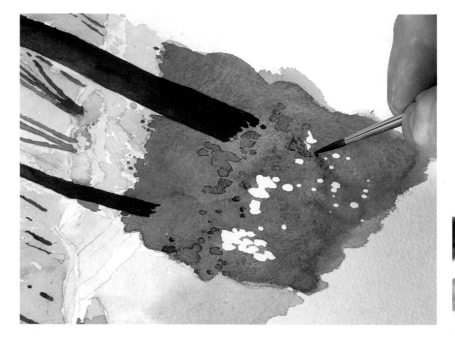

tip

Practise half-mixing col-ours on the palette; the results you can get with varied pigments on the brush and paper can make all the difference to a painting, particularly one that tries to capture the light effects of a spring day.

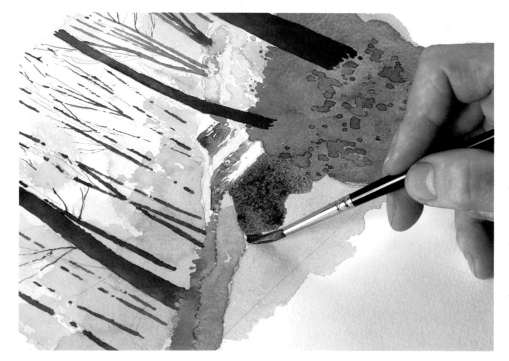

step eleven

For the shadows on the path, apply a mix of burnt sienna and French ultramarine, darkening this in the foreground.

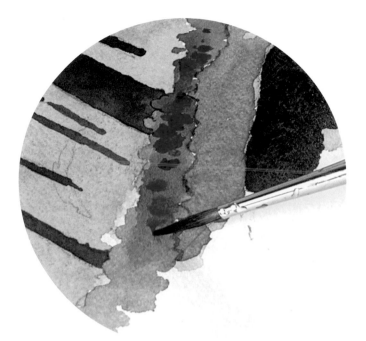

tip
To avoid overworking details, for instance the mass of flowers, try squinting at your subject. This will reduce the details to a minimum.

step twelve
When the bluebell wash is dry, make up a stronger blue and violet mix, then add this carefully to create some shadowed areas.

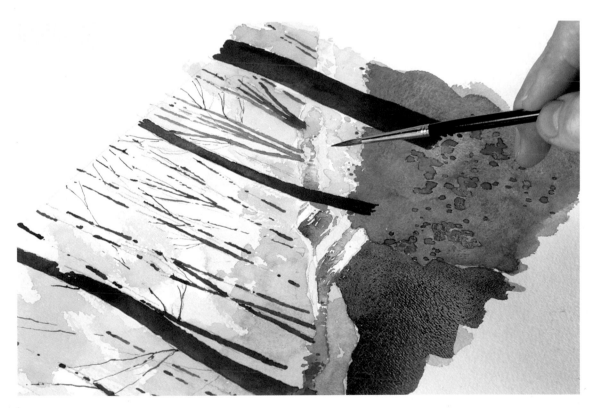

step thirteen
Make up a very pale bluebell mix with more blue than violet, and use the No. 4 brush to dot in some flowers lit by the sun in the background. Leave some patches of white paper to intensify the effect of light.

rural road

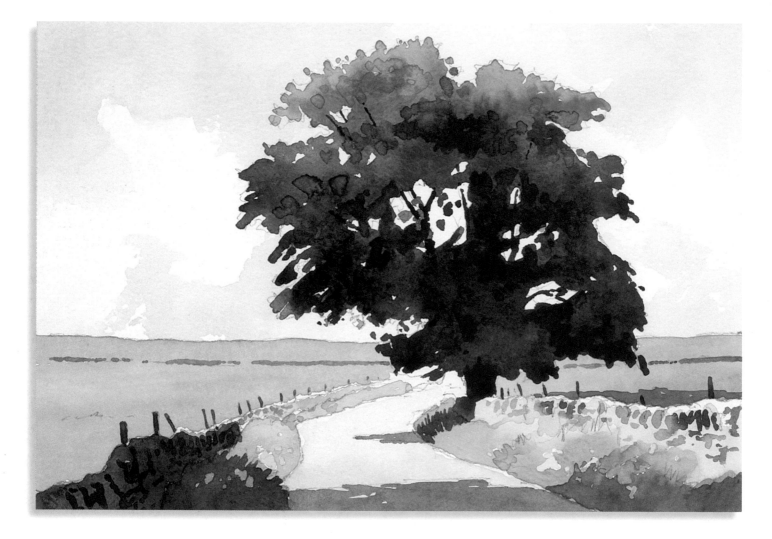

Paintings of summer can look totally lifeless unless a strong sense of light and shade is present. I chose this scene for the simplicity in its content – a summer tree, green fields, the suggestion of one or two wild flowers and some cast shadow. My main objective was to build up the general colours first, followed by the shadow areas, and to finish off with the darks and details. The tree is the main focus of the painting and needs to be bolder and more detailed than the other elements of the scene.

you will need

French ultramarine	sap green	Payne's grey	lemon yellow	raw sienna	burnt sienna	light red

brushes & other equipment:
- Nos 12, 8, 6 and 4 round •
- Bockingford NOT 410gsm (200lb) paper

step one

Start by applying a few random dots of masking fluid on the flowers on the banks of the road, using the tip of a small brush handle. Don't overdo the amount you put on. Allow the masking fluid to dry completely.

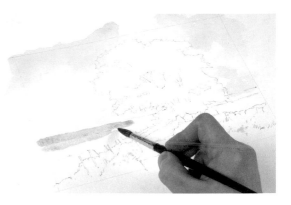

step two

Add the sky with a weak scumbled wash of French ultramarine, using the side of a No. 12 brush, then add some light red to the mix for the lower part. Switch to a No. 8 brush for the fields, with a mix of sap green and lemon yellow.

step three

Add a little French ultramarine to the green mix as you approach the right-side wall. This helps to suggest the cooler, shaded area.

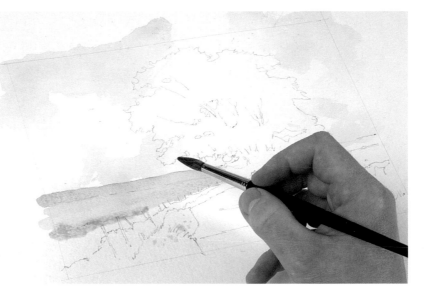

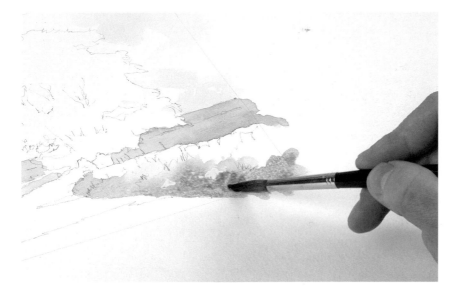

step four

Dilute the green mix for the foreground and paint this over the masking fluid, then add some French ultramarine for the shadow areas in the banks. Wash out the brush and use clean water to soften the mix as it goes up to the wall on the right. Repeat this on the left side of the picture.

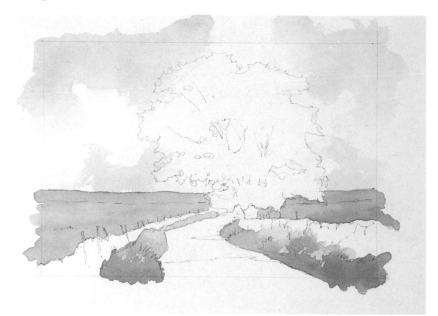

step five

For the lightest part of the tree, where the sun hits the the top foliage, apply a mix of sap green and lemon yellow with the No. 8 brush. Use a stippling technique for the edges, and look for the mass of leaves, rather than individual ones.

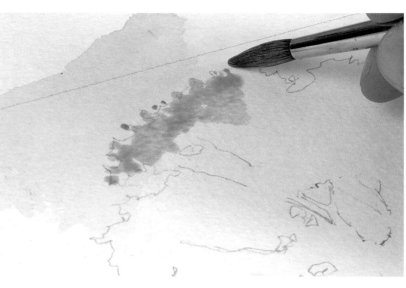

step six

While this is still wet, apply a quite strong mix of sap green and French ultramarine for the cooler parts of the foliage. Stipple the edges as before, and make sure to leave some white paper showing through.

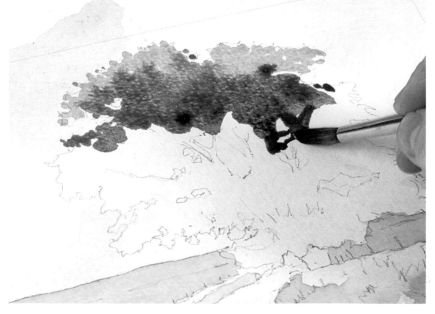

tip

If you've overdone the masking fluid, you can speed up its drying time by touching off the excess fluid with the tip of a tissue or piece of kitchen roll.

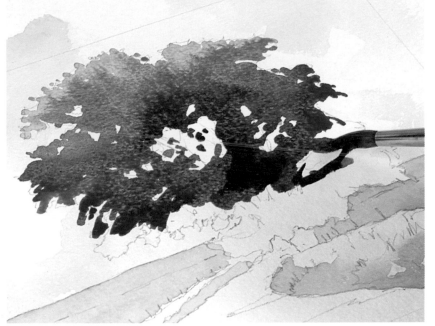

step seven
While the last wash is still wet, add Payne's grey to the mix for the darkest parts of the foliage. To bring the wash down evenly, alternate the applications across the whole tree so as to keep the effect flowing.

step eight
When the first washes have dried, use a strong mix of Payne's grey, French ultramarine and sap green for the shadows in the very darkest parts of the tree.

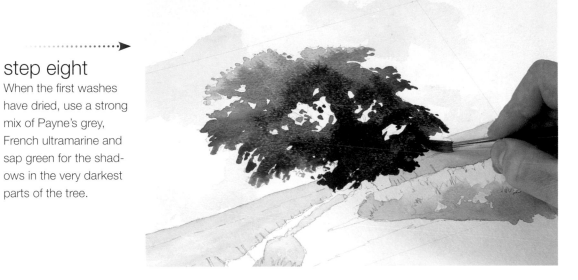

tip
Keep shadows to the bare minimum for maximum effect – too many will not look good.

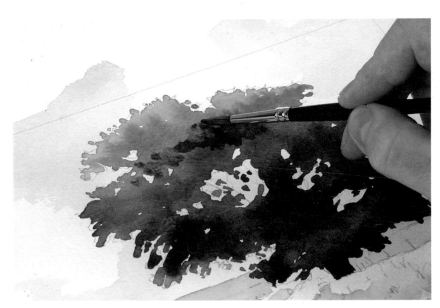

step nine
Use a No. 6 brush to stipple on this mix to the finer, darker parts of the foliage, then add clean water to soften these areas – use the pigment as a reservoir.

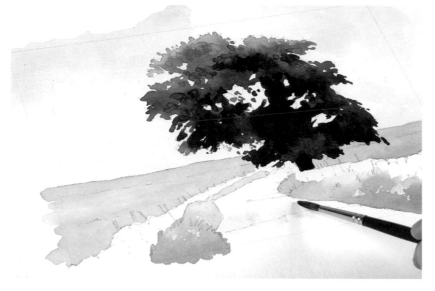

step ten

Apply a pale mix of raw sienna for the road. Increase the strength of the mix towards the foreground, and add burnt sienna for warmth. Use alternating washes of raw sienna, and a mix of light red and French ultramarine for the walls and the fence posts on either side.

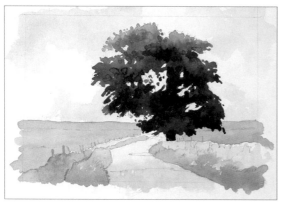

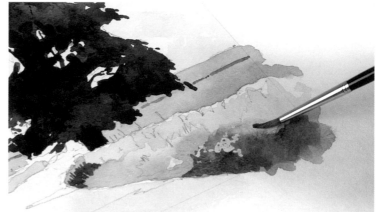

step eleven

For the distant wall in the field, use a No. 4 brush to apply a wash of burnt sienna with a touch of Payne's grey – this is not a straight line, but should be added using a light, lost-and-found technique. Use Payne's grey with a little burnt sienna for the branches showing through the tree foliage – again, don't overdo this. For the greenery on the bank, use a mix of sap green and French ultramarine, softening it with clean water. Show the contours by painting with the curves of the bank rather than in straight lines.

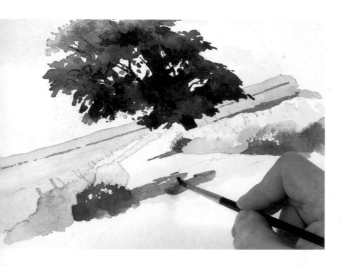

step twelve

Mix French ultramarine and light red for the shadows across the road. Start by joining the mix to the shadows on the right bank, then build up the mass using side-to-side strokes, stippling the mix at the edge. Use the same mix for the shadows on the left-hand wall.

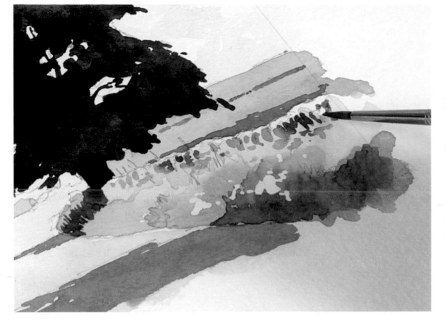

step thirteen

With the picture dry, rub off the masking fluid with clean fingers. Add some touches of sap green to the banks for emphasis, softening them with clean water. For the stonework on the right-hand wall, use a mix of French ultramarine with a touch of burnt sienna – don't attempt to show contours or details, but just suggest the stones.

tip

Build up shadows with different washes, rather than applying one solid block of colour.

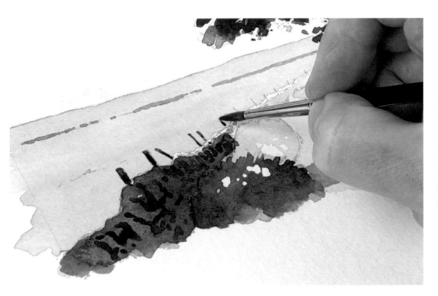

step fourteen

Make up a much darker mix of the stone colour for the left-hand wall, and apply it using larger marks; dilute the wash for the lighter sections. Apply a dark mix of burnt sienna and French ultramarine for the fence posts.

step fifteen

Still with the dark mix, put in a few small branches in the foliage. To finish, apply lemon yellow for the flowers – don't cover the whole space, but leave a little white – and add a little light red and French ultramarine to the yellow for the flowers in shadow.

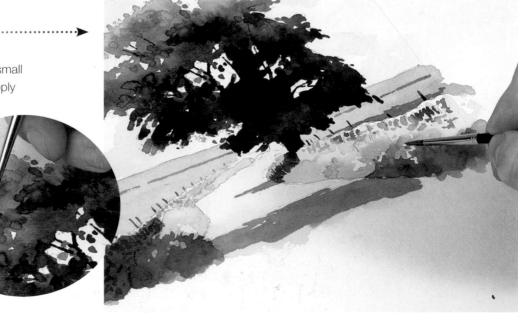

seasonal woods

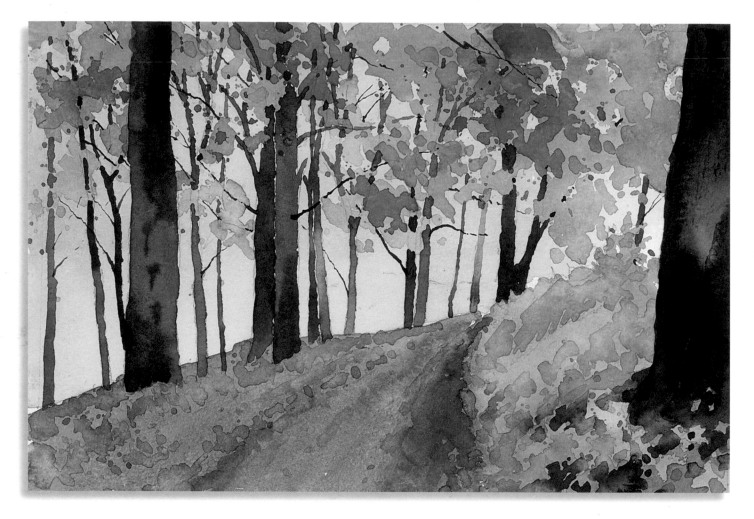

This project is centred around capturing the sparse but varicoloured canopy of autumn leaves. Make sure that you use fluid washes of paint, so that they flow and run together as you spatter and stipple to achieve the texture of the leaves, both on the trees and the ground. Try not to overstate the trees – for example, by painting every single leaf – a broad suggestion is far more effective, as this helps the viewer to use his or her imagination to fill in the gaps.

you will need

| light red | raw sienna | lemon yellow | sap green | Payne's grey | French ultramarine |

brushes & other equipment:
Nos 8, 6 and 4 round, and No. 1 rigger • Bockingford NOT 410gsm (200lb) paper

step one

With a No. 8 brush, apply a very pale wash of light red across the top of the picture; add a touch of French ultramarine for the next layer, and switch to sap green for the field. Keep the washes fluid, so they flow into each other.

step two

With the background washes completely dry, mix together light red and lemon yellow loosely on the palette, then spatter this on to the top of the picture, mopping off any unwanted patches immediately with a clean tissue.

step three

Next, clean the brush and spatter on clean water. Stipple the pigment and water together so as to achieve a lively, varied pattern that is loose and quite unpredictable. Either this technique works or it doesn't!

step four

You can use a clean finger to spread and soften the spattered and stippled paint – but don't overwork this, otherwise you may lose the freshness and feeling of spontaneity.

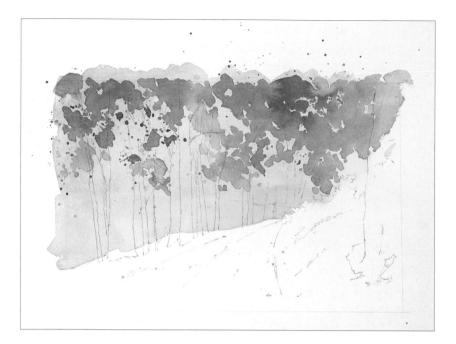

tip

Spattering produces large and small dots, which are perfect for giving a suggestion of the varied sizes and colours of autumn leaves – and are far preferable to trying to paint in each individual leaf or series of leaves.

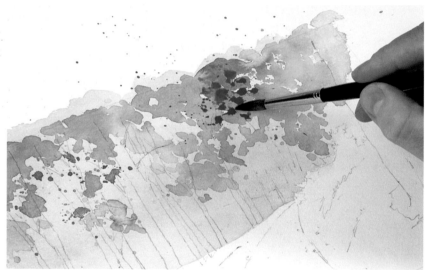

▲ step five

Allow the first spattered wash to dry, then make a stronger mix of the red and yellow. Spatter, stipple and spread this as before, but do so sparingly – you don't want to cover the first layer, but add to it for depth and variety.

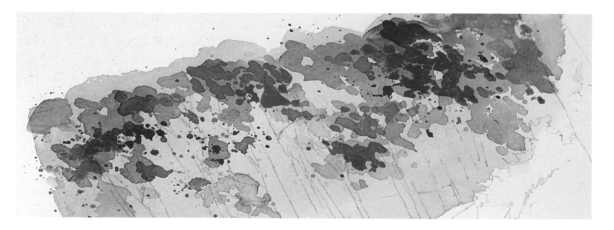

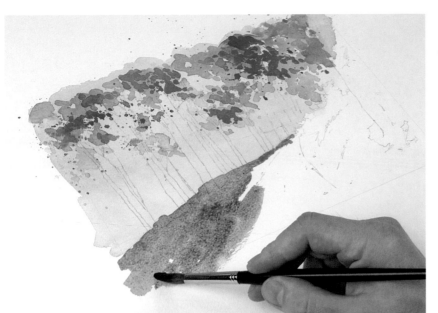

step six

Apply a light wash of the leaf colour for the fallen leaves on the left of the track, mixing the colours as much on the paper as on the palette. While this is still damp, add a mix of French ultramarine and light red for the track so that it merges with the leaf mix.

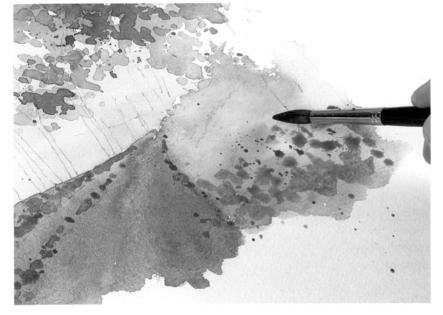

step seven

Again while the track wash is damp, add the leaf wash to the right-hand side. Deepen and dilute the wash here and there to suggest the variations in leaf colour, but don't try to add detail at this stage. Allow to dry.

step eight

With a little French ultramarine added to the leaf mix, spatter this darker colour on to both verges, again not covering the first wash. Stipple some lines of leaves along the sides of the track, making sure that these are not too regular. You can be a little more free on the right verge, using the wash to give a vague idea of the contours of the ground.

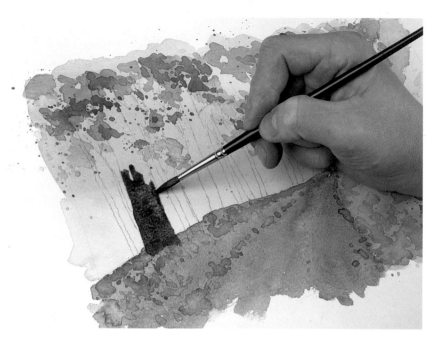

▲ step nine

Switching to a No. 6 brush, apply a mix of sap green and Payne's grey to the tree trunks. While this is wet, add a slightly darker version of the mix to give variations in colour and texture.

step ten

Where the smaller tree trunks and branches disappear behind leaves and foliage, use a lost-and-found technique to portray the effect.

tip

Remember that trees in the distance are fainter, so make them lighter and cooler.

step eleven

Use a No. 1 rigger and a darker mix for the smallest branches. Make sure the lines of the branches are accurate when they reappear.

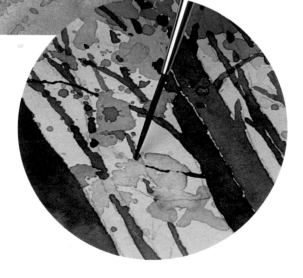

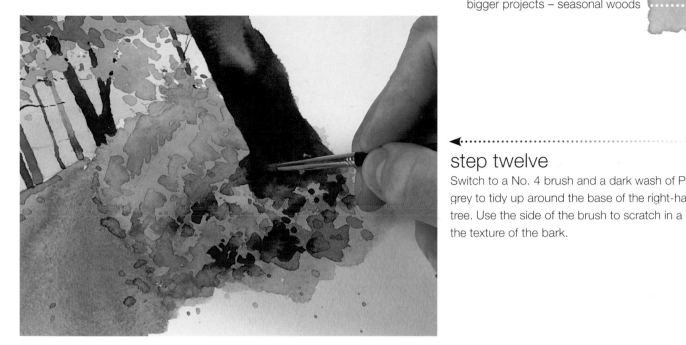

step twelve

Switch to a No. 4 brush and a dark wash of Payne's grey to tidy up around the base of the right-hand tree. Use the side of the brush to scratch in a bit of the texture of the bark.

step thirteen

To add definition to the trunk, apply a mix of French ultramarine and light red, working quickly; then wash the brush and soften the colour with clean water.

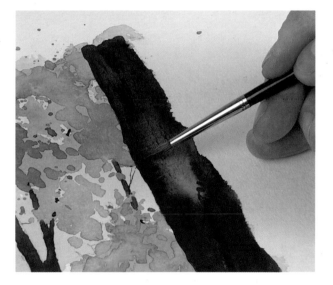

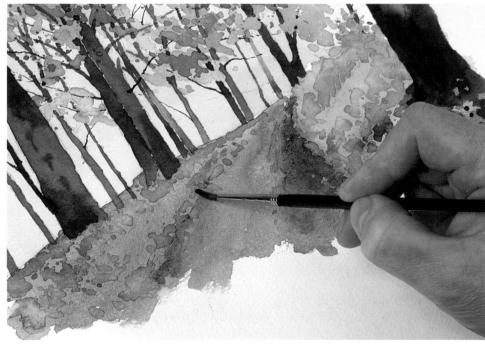

step fourteen

The track shouldn't be uniform in colour, so use a darker wash of French ultra-marine and light red to suggest ruts and hollows. Finish by going over the fallen leaves on the track with a very diluted version of the mix.

snow scene

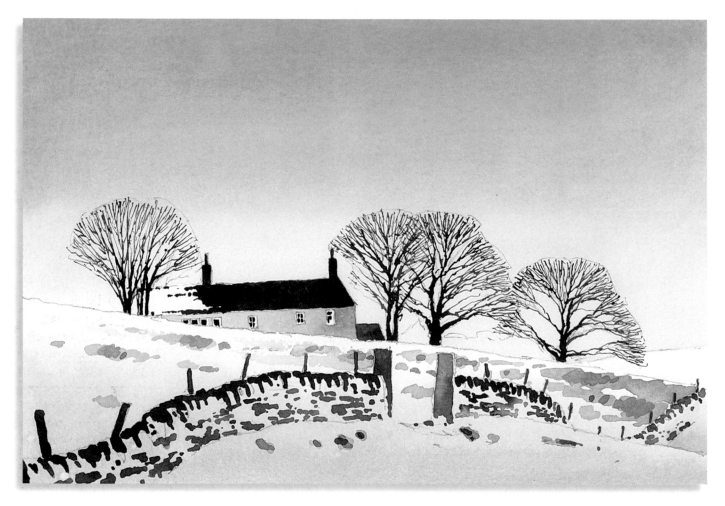

This painting involves contrast and careful brush control, and is a good exercise for dealing with tonal work. Snow tends to emphasize contrast within a landscape, as most of the tones become the lightest part of the tonal scale; everything else, unless lit by sunshine, appears darker by comparison. Try to reflect this in your painting by deliberately mixing the darker tones much stronger than you might normally do. The trees are dealt with in the same way tonally, although the canopy of fine twigs is a wonderful exercise for using a fine rigger brush.

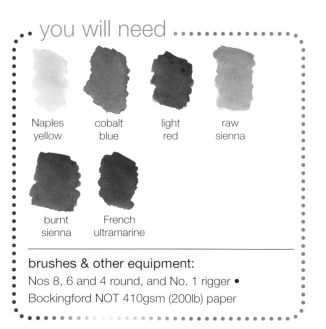

you will need

Naples yellow	cobalt blue	light red	raw sienna
burnt sienna	French ultramarine		

brushes & other equipment:
Nos 8, 6 and 4 round, and No. 1 rigger •
Bockingford NOT 410gsm (200lb) paper

step one
Using a No. 8 brush, paint a very fluid, light wash of Naples yellow from the treetops to the horizon line, leaving the buildings white.

step two
While this is still wet, apply a gradated wash of cobalt blue from the top of the picture to the first wash, blending the blue into the yellow where they meet. Add more blue at the top while the first wash is wet.

tip
Tilt the picture when applying the sky washes, so the paint can run down the paper a little.

step three
Wet the bottom area of the picture, then apply a mix of cobalt blue and light red, but this time adding more water to the mix as you go towards the middle. Allow all the washes to dry.

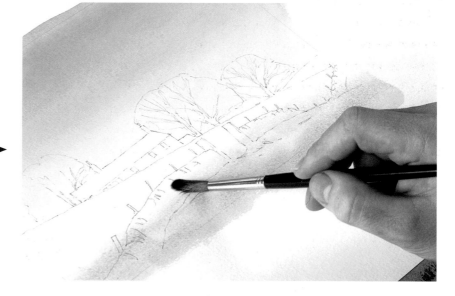

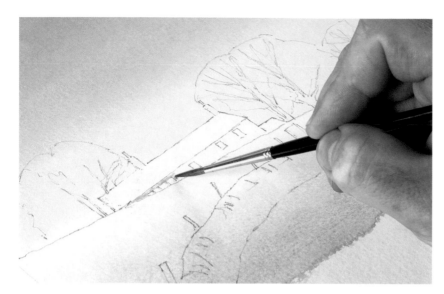

tip

Even after a fall of crisp white snow, there are still many contours in the ground that can be shown as shadowed areas, so don't stint on the colours when painting snow scenes.

step four

Switching to a No. 4 brush, paint the walls of the house with raw sienna; drop burnt sienna and French ultramarine into the wash on the right side. Allow this wash to dry.

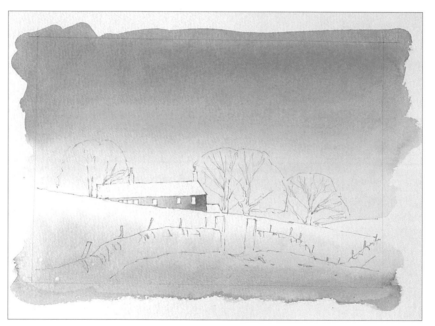

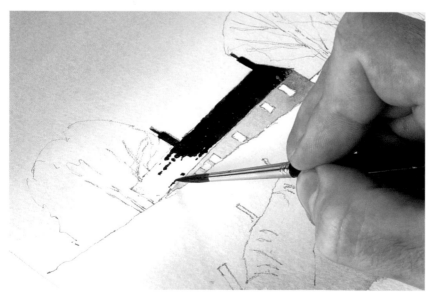

step five

Paint the roof and the chimneys using a thick, dark mix of French ultramarine and burnt sienna. Leave the left side white for snow, and just stipple a few bits of roof showing through.

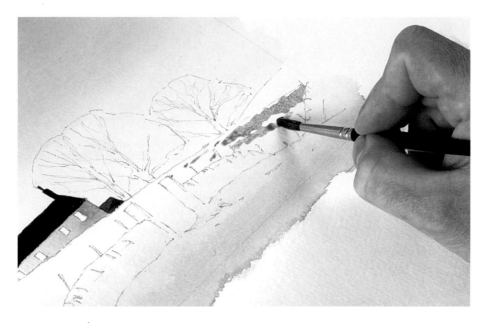

▲ step six

With the No. 6 brush, apply a mix of raw sienna, burnt sienna and a little French ultramarine as 'broken colour' to create patches where the earth is not covered by snow.

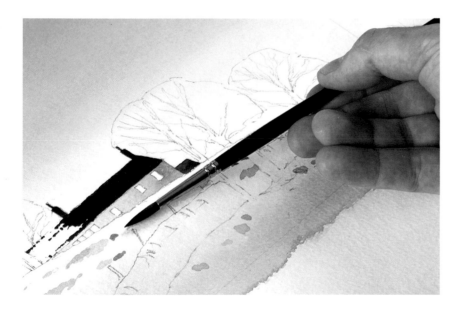

tip

Constantly think about the relationship of brushstrokes to the landscape features. If there are rugged, broken textures to paint, don't try to copy them exactly. Use drybrush or stippling techniques to suggest the effect.

▲ step seven

Vary the strength and amounts of each pigment for these areas, and use a drybrush or stippling technique to create texture. As the washes dry slightly, strengthen them with slightly darker mixes, blending these into the first washes. Don't put in too much bare ground, or you run the risk of losing the quality of the snow.

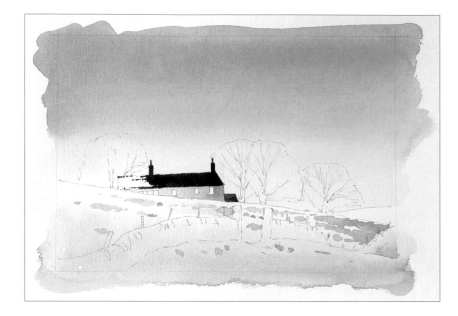

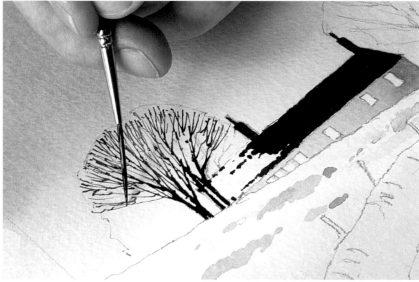

step eight

Make up a dark mix of burnt sienna and French ultramarine, and use a No. 1 rigger to paint the trees; these are in silhouette, so you don't have to worry about tonal variations other than those made by the pigment itself.

tip

Don't try to rush close, detailed work, however near to the end of a painting you are.

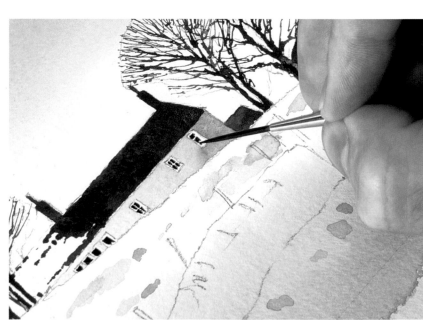

step nine

Use the same brush and mix to just dot in the window panes.

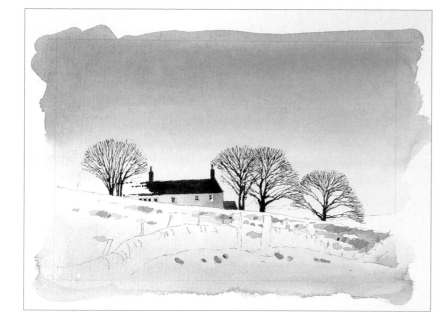

tip

If you have unwanted blobs of pools of paint in your picture, soak them up with a dry brush.

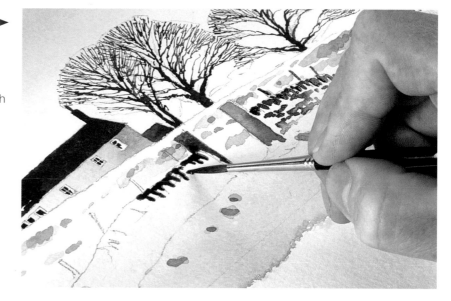

step ten

With the No. 4 brush, apply a lighter mix of burnt sienna and French ultramarine, brushing vertically for the top stones of the wall.

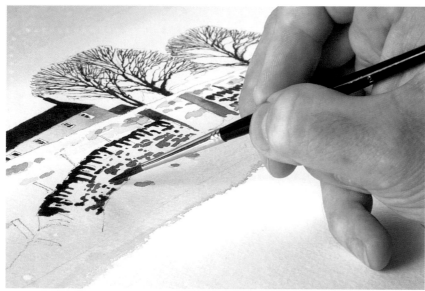

step eleven

Dilute the mix and add raw sienna for the horizontal stones in the wall itself; use varying amounts of pressure for variety. Paint the gateposts with raw sienna, and finish by dotting in a few darker patches of bare earth in the foreground, using the tree mix diluted.

light and shade

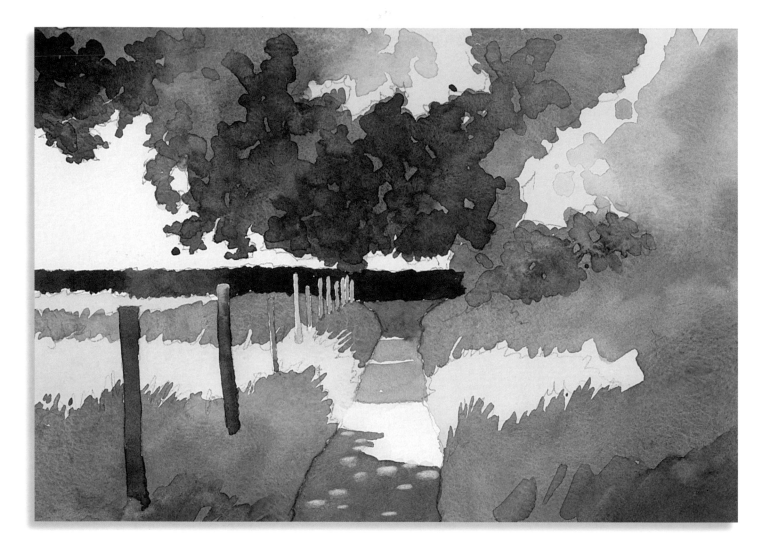

Light will only appear as light if it is contrasted with darker tones. When trying to lighten an area, artists will often add white paint or scrape paint off the paper, in both cases without much success – the true way to make light areas appear brighter is to add stronger, darker paint elsewhere in the painting. I chose this scene as a good example of painting light and shade because of the properties in it associated with light in the landscape: light-struck areas, dark areas of shade and cast shadows.

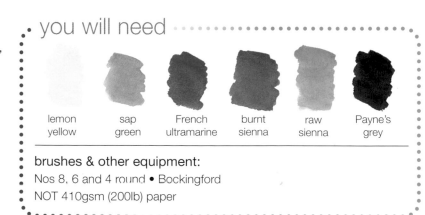

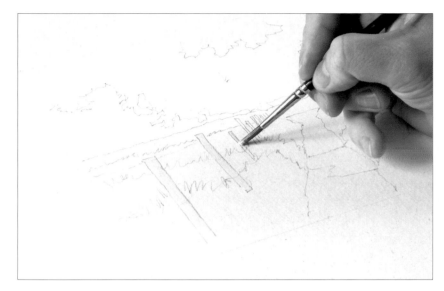

step one

Use a No. 4 brush to paint masking fluid over all the posts – don't use your best brush for this, as even if you clean the brush immediately after use, a little residue of the latex fluid will remain and clog up the hairs. (But still clean up even your second-best brushes.) Allow the masking fluid to dry.

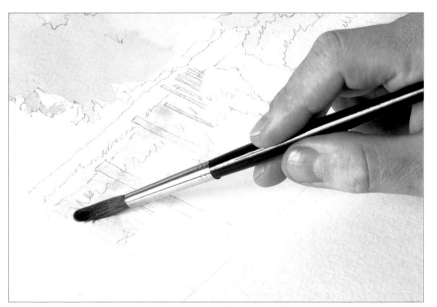

step two

Make up a fluid mix of lemon yellow and sap green, and use a No. 8 brush to paint this over all the foliage and grassy areas; mix the colours on the paper to give a varied effect.

step three

Using the same brush and apply a mix of sap green, French ultramarine and Payne's grey to darken areas of the foliage. Don't aim for a uniform shade, but vary the amount of each pigment in the mix to keep everything interesting, and use a dry brush to leach out any excess colour.

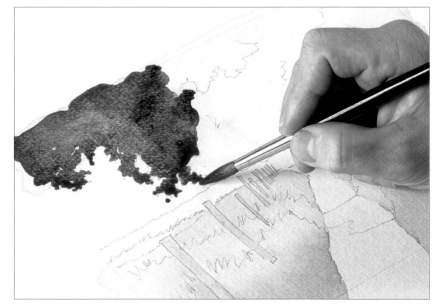

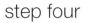

step four

With a slightly stronger, fluid version of the green mix, paint the dark grass in the foreground on the right of the path. Mix the colours on the paper to add variety, and cut into the first light wash using negative painting.

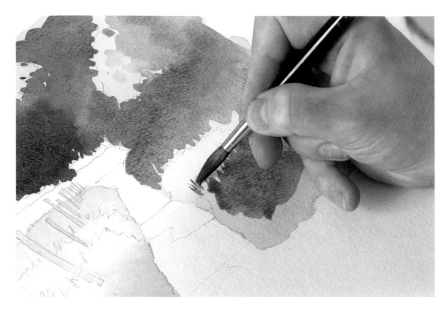

step five

For the furthest line of foliage behind the posts, add more Payne's grey to the green mix and paint it over the posts. Once again, paint into the lighter washes, using the very tip of the brush.

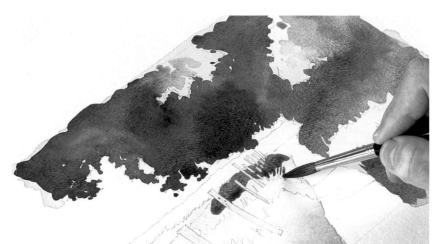

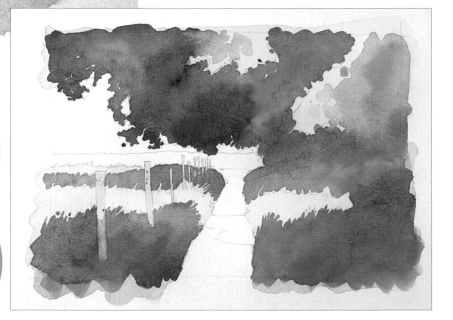

tip

To paint negative shapes, first draw out the grasses in pencil so that you can see where to paint up to.

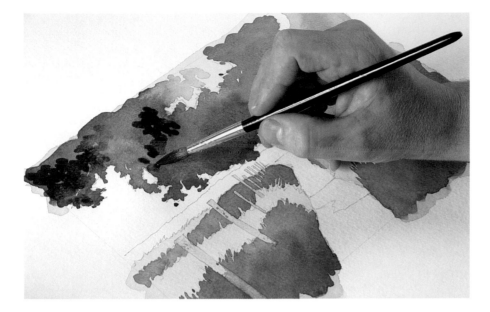

step six

When the foliage is completely dry, make up a dark mix of French ultramarine, Payne's grey and sap green and apply the darkest shadow areas in the trees. Let each wash dry a little before adding darker washes – but don't overdo the effect by putting in too much shadow, as it is the contrast that draws the eye.

step seven

For the wall, make a strong mix of burnt sienna and Payne's grey, adding more sienna as you go into the lighter areas. Remember that watercolour paint dries a lot lighter on the paper, so don't be afraid to go in quite dark from the start.

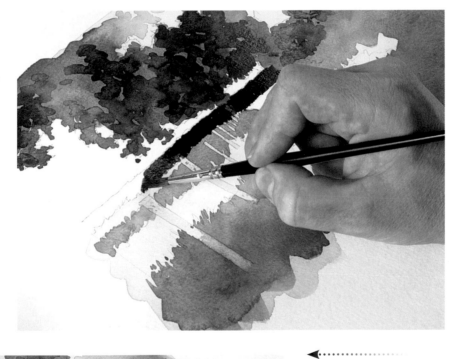

step eight

Start the path with a diluted wash of raw sienna, leaving white paper for the lightest areas; add a touch of burnt sienna to warm up the foreground parts.

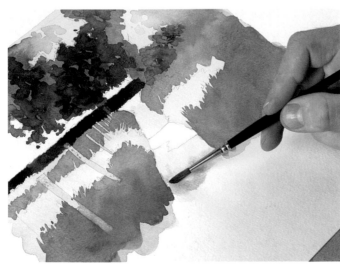

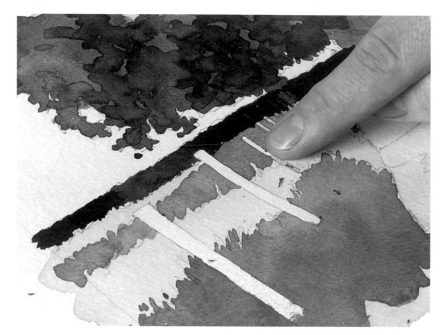

step nine

With the picture completely dry, rub off the masking fluid to expose the paper beneath. Make sure your finger is clean, otherwise you may smudge the surrounding painted areas.

step ten

Use a mix of burnt sienna and Payne's grey for the posts in shadow, with a touch of darker colour along the side that faces away from the light.

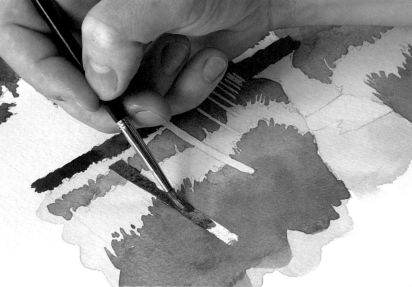

step eleven

Lighten the mix for the posts the further away you go, and then switch to using raw sienna for the furthest posts.

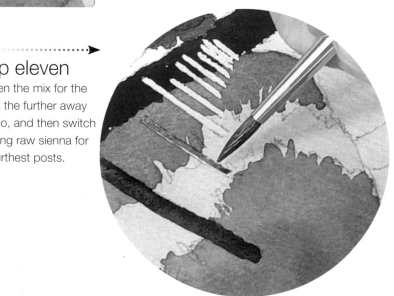

tip

Leave a strip of white along one side of the furthest posts, to suggest highlights where the sunlight hits the post.

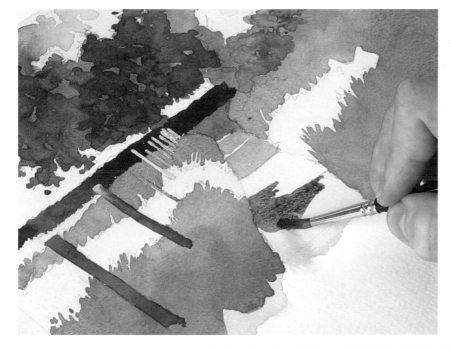

step twelve

Switch to the No. 6 brush to put in the shadows across the path, using medium-strength mixes of French ultramarine and burnt sienna for the foreground areas and progressively lighter ones in the distance. Look for changes of tone in the mixes.

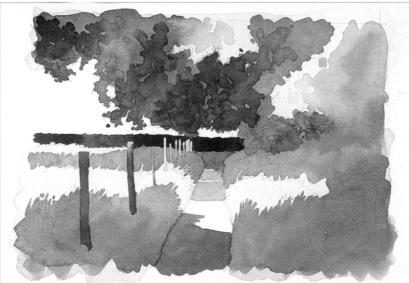

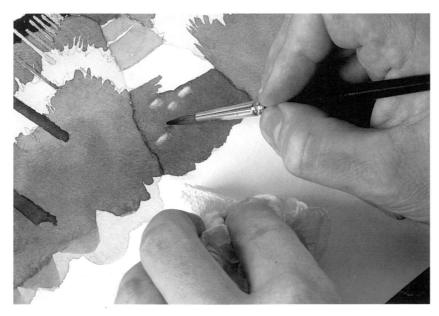

step thirteen

Allow all the washes to dry. For the dappled spots of light in the shadows, apply a little clean water to lift off the dry pigment with the brush tip, and then dab off the residue of water and pigment with a clean tissue or kitchen roll. Use the same technique to soften the edges of the path that are in bright light. To finish, apply some dark green mix to the grass at the very bottom of the picture.

waterfall

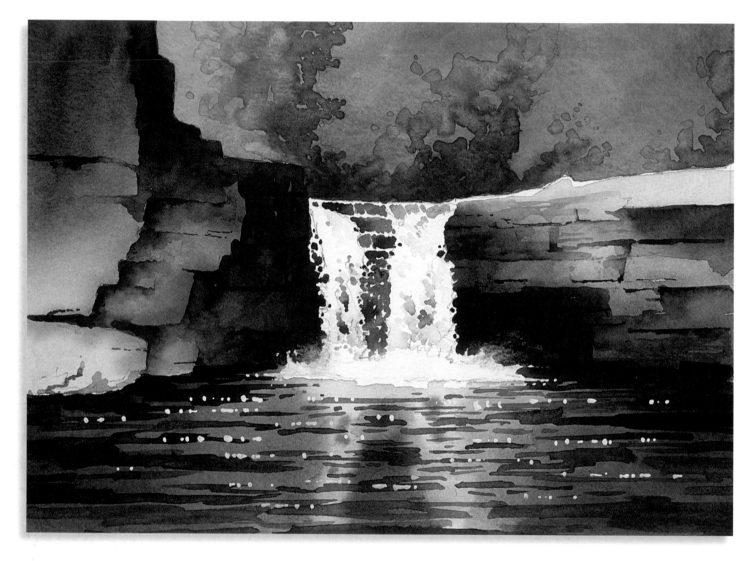

Waterfalls are often seen as confusing and too difficult to paint, but treat them as you would any other exercise in watercolour – start with the lightest parts, in this case the falling water. A gentle stippling technique combined with softening using clean water is an excellent way to suggest the soft changes of tone within the waterfall itself. The main aim of this painting is to concentrate on the contrast between the light water and the darker surrounding rocks, as this will help to give the waterfall a light, translucent appearance.

you will need

| French ultramarine | sap green | raw sienna | burnt sienna | Payne's grey | white gouache |

brushes & other equipment:
Nos 12, 8, 6 and 4 round, and No. 1 rigger • Bockingford NOT 410gsm (200lb) paper

step one

Using a No. 4 brush, stipple a light wash of French ultramarine for the shadow parts of the waterfall, then wash out the brush and use clean water in order to soften the edges.

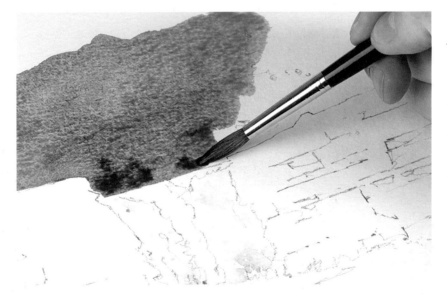

step two

Switch to a No. 8 brush to apply a strongish wash of sap green for the light parts of the background foliage. Add some French ultramarine to this while it is wet, and then a little Payne's grey to the lower parts. Allow to dry.

step three

For the left-hand rocks, apply raw sienna to the lightest parts, then while this is wet, blend in some burnt sienna and finally a darker mix of burnt sienna and Payne's grey. Use the side of the brush to merge the darkest colour into the sienna of the rock and the tip of the brush to paint up to the green background.

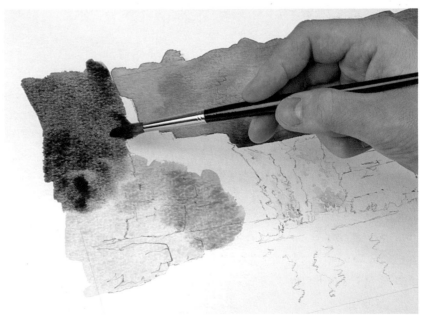

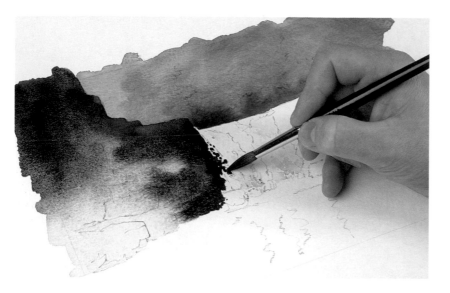

tip

Paint the mass of rocks first, working your way towards the edge of the waterfall. Then, when you stipple in the broken edge, the image will be clearer to see as you paint.

step four

Use the very tip of the brush to add some fissure lines in the rocks before the washes have dried, with the dark mix. With the same brush, make a stippling effect down the side of the water to show a few rocks underneath the spray.

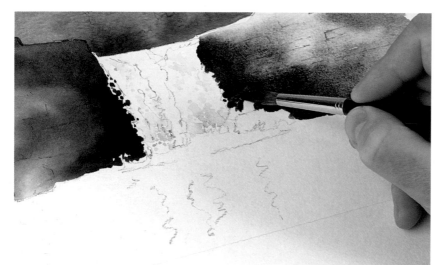

step five

Repeat the painting of the rocks on the right-hand side, taking care to keep the mixes varied. Remember also not to overdo the stippling for the rocks behind the waterfall. Use a No. 6 brush and a mix of sap green and French ultramarine with a touch of Payne's grey for the trees above the water – these should be no more than a rough impression – soften the edges with clean water.

step six

Apply a mix of burnt sienna and Payne's grey with a No. 4 brush for the rocks in the waterfall; keep the washes varied in strength, and leave gaps for the splashes.

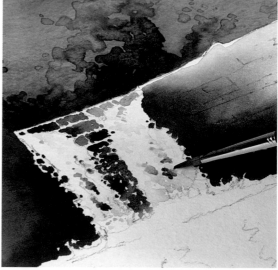

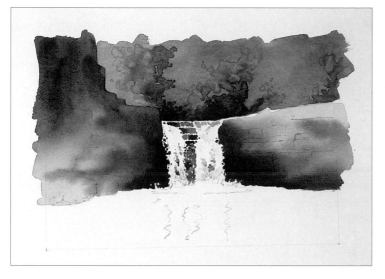

tip

To save time in the details, use two brushes, one for the paint and one for the clean water.

step seven

Make up a quite dark mix of Payne's grey and burnt sienna, and apply this with the No. 6 brush for the main shadow areas on the rocks. Add more Payne's grey as you go down towards the water, and emphasize the fissures and rock formations, softening the lines with clean water.

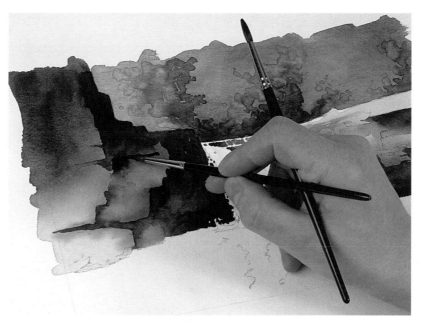

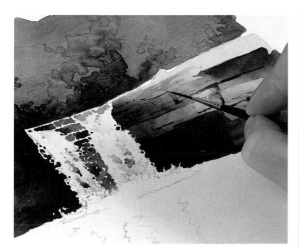

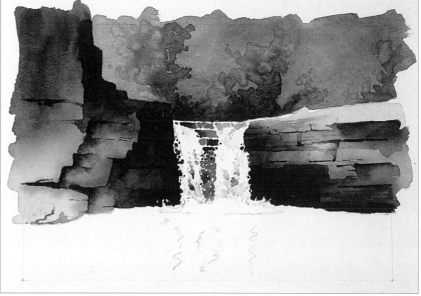

step eight

Switch to a No. 1 rigger and a very dark mix for the finest details; but don't be tempted to put in every last detail.

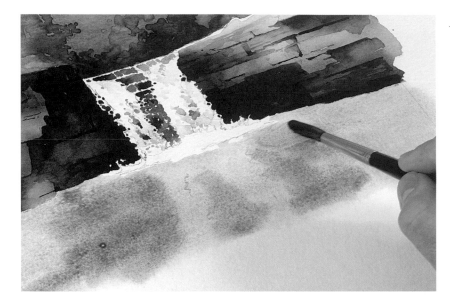

step nine

With a No. 8 brush, apply clean water to the whole area of water, except directly below the waterfall. While this is still wet, add a medium-strength wash of French ultramarine over the wetted area up to, but not over, the bottom of the rocks. While this wash is wet, go over it with sap green to show the rough reflections of the trees and darker rocks.

step ten

For the areas of water at the side, add some Payne's grey to the sap green and brush this on while the water area is still wet.

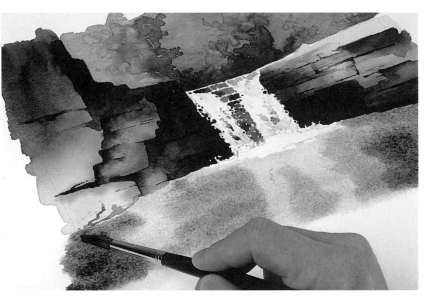

tip

When painting reflections, finish off the land details above first. This way you can see which features, colours and tones you need to reflect.

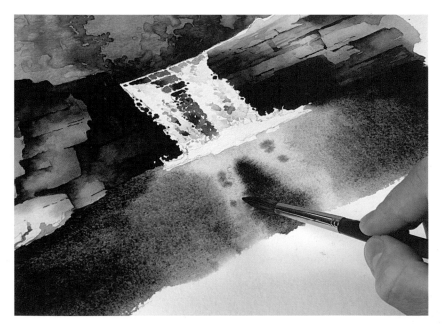

step eleven

To reflect the central rocks, apply a mix of Payne's grey and burnt sienna over the still-damp sap green. Allow these washes to dry.

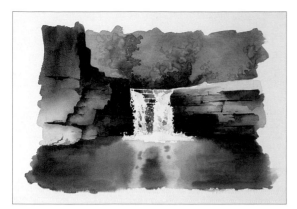

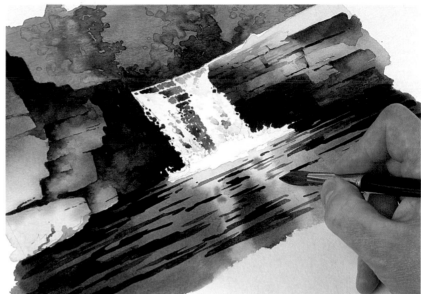

step twelve

Load a No. 12 brush with a mix of Payne's grey and a touch of burnt sienna, and apply side-to-side brushstrokes for the ripples of the water. Vary the pressure you put on the tip of the brush to produce varied widths of stroke. Allow to dry.

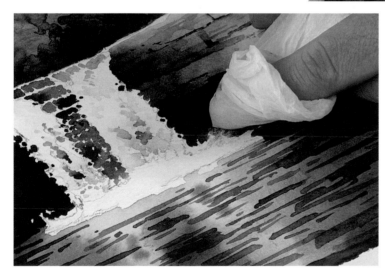

step thirteen

To create a misty effect where the falling water meets the rocks, dampen a tissue with clean water, squeeze it out and gently go over the paint. Keep rotating the tissue so as to get a clean surface for removing just a little pigment – work carefully, so you don't remove too much.

step fourteen

Dip the No. 4 brush directly into a tube of white gouache, and dot the high-lights into the ripples. You can also use white gouache to add any last white to the falling water or splashes.

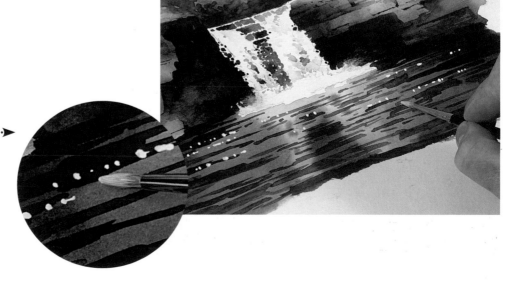

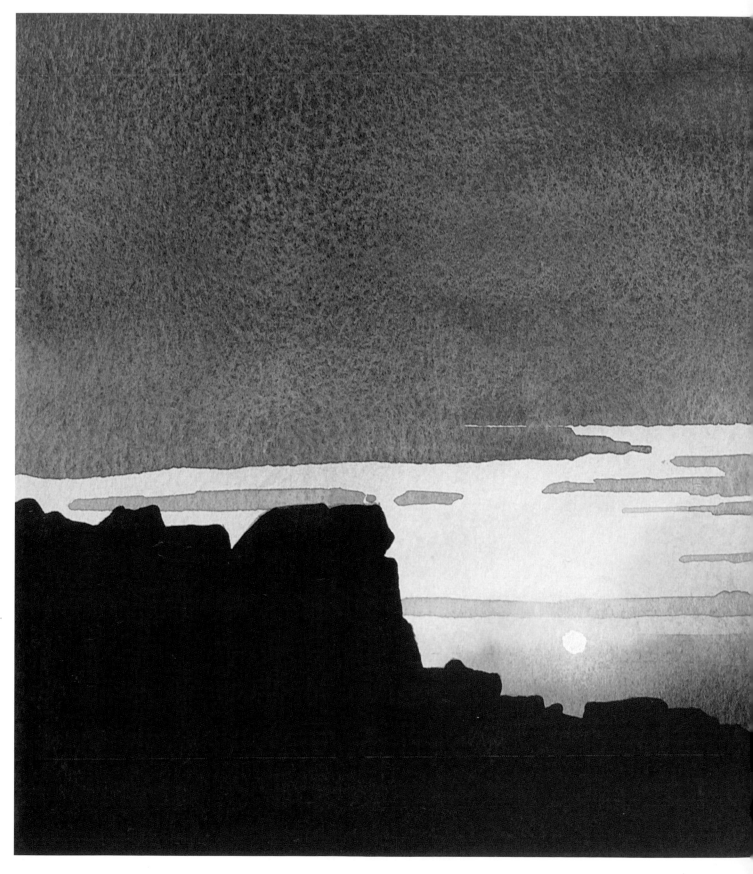

Winter Sunset from Blackstone Edge
17.8 x 22.9cm (7 x 9in)

In terms of subject matter, this is about as simple as they get. The dark silhouetted rocks required very little detail, as the emphasis of the painting is placed on the sun. This was masked out initially and the rest of the painting was built up, making sure that all the white paper was washed over. When the masking fluid was at last removed, the sun became the only white in the painting and hence the lightest part of the scene.

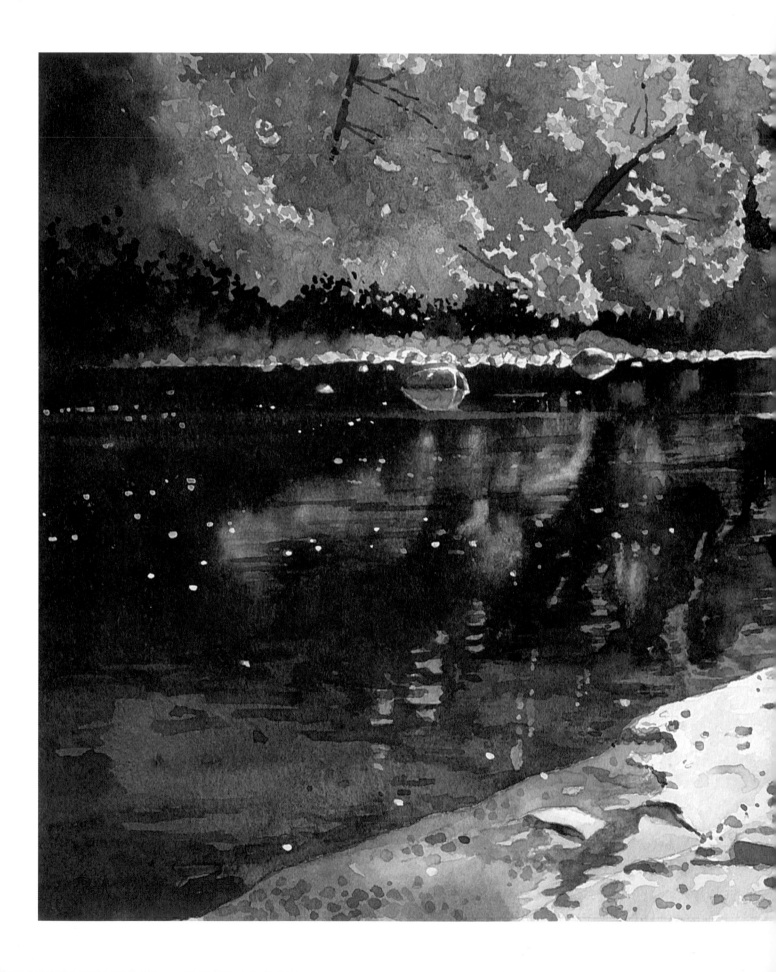

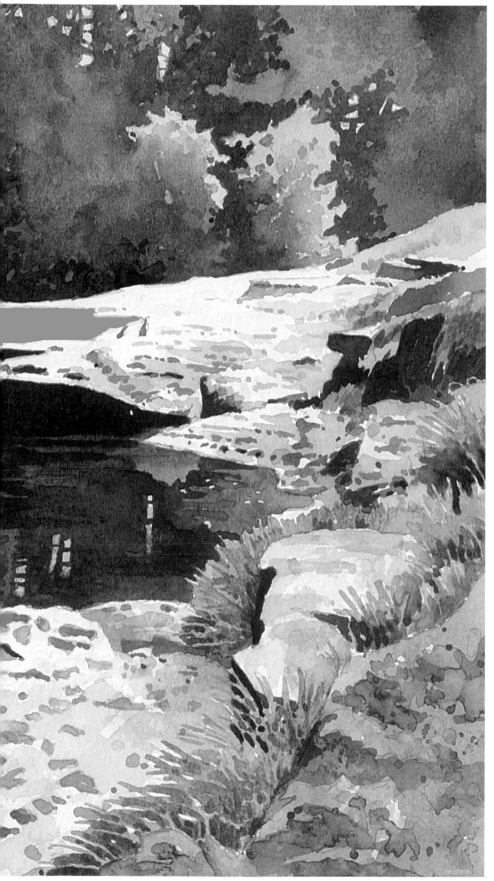

The River Ribble at Stainforth
22.9 x 30.5cm (9 x 12in)
In this scene I have tried to increase the aerial perspective by making the background trees much cooler in colour than they actually were. The water was painted wet-into-wet with very strong paint, and the finer details were reserved for the immediate foreground only.

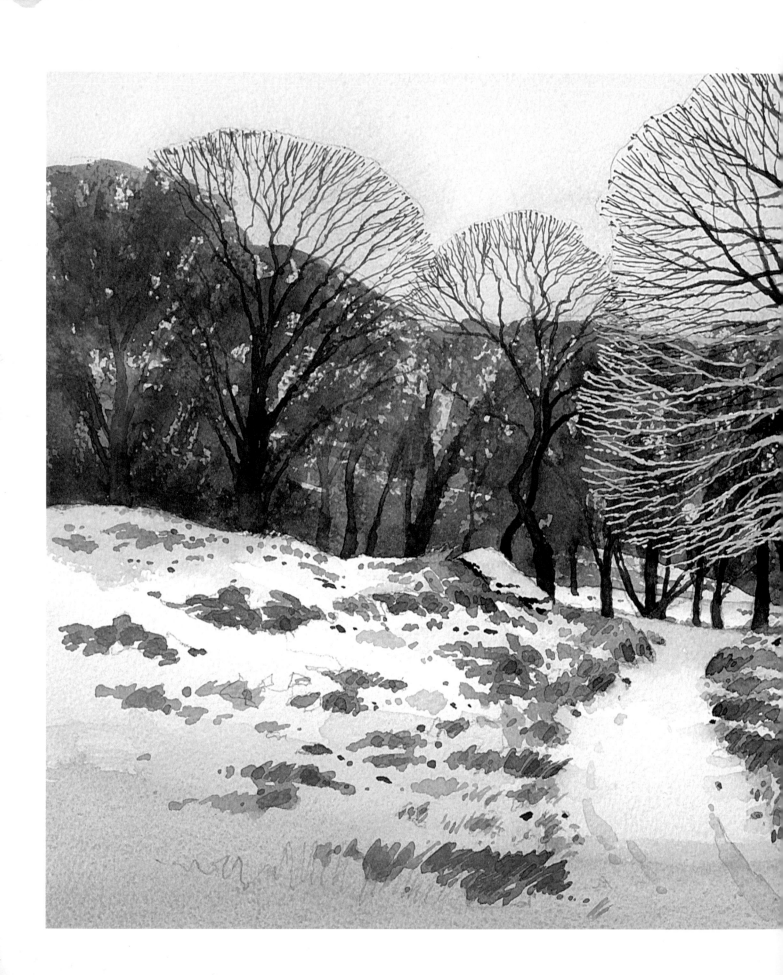

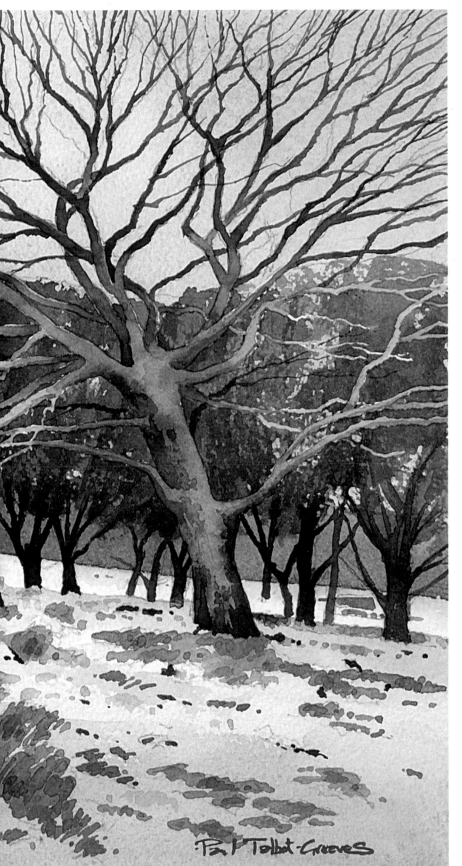

Turning Dusk in the Chew Valley
22.9 x 30.5cm (9 x 12in)

Quite often it is the least obvious subjects that
make the most rewarding paintings. This scene
drew my attention to the changes in tone within
the main winter tree – dark against light in the
sky area, and light against dark against the
background trees. The lighter twigs and branches
were masked out with masking fluid and a dip pen
at the early stages of the painting. Look out for
these subtle changes in your own paintings, as
they can make such a difference.

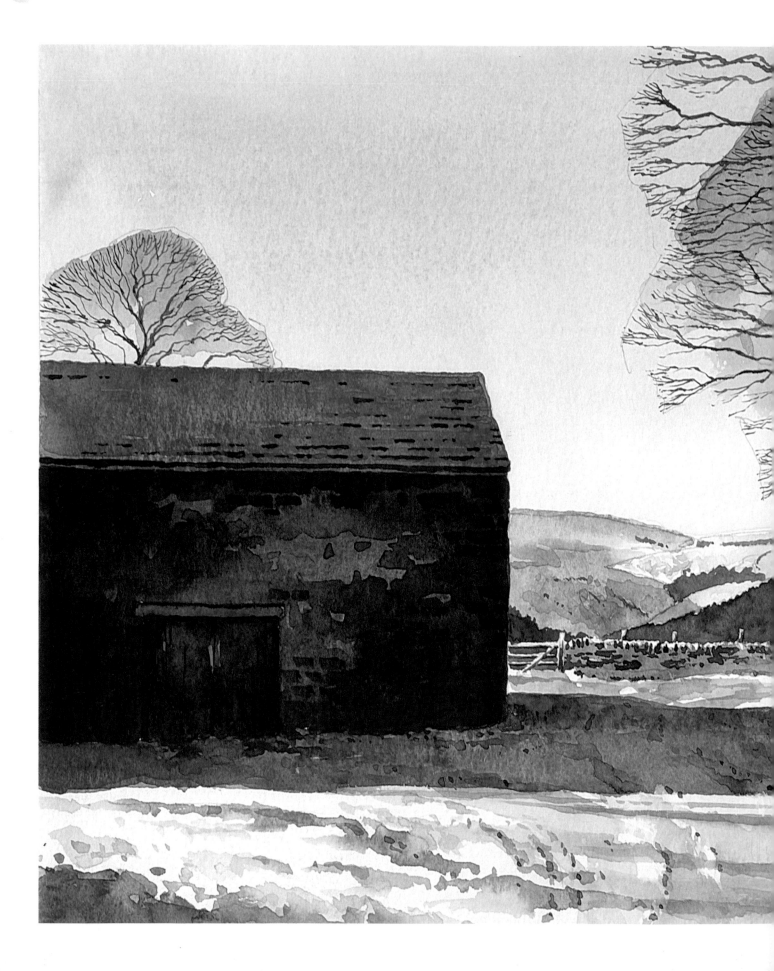

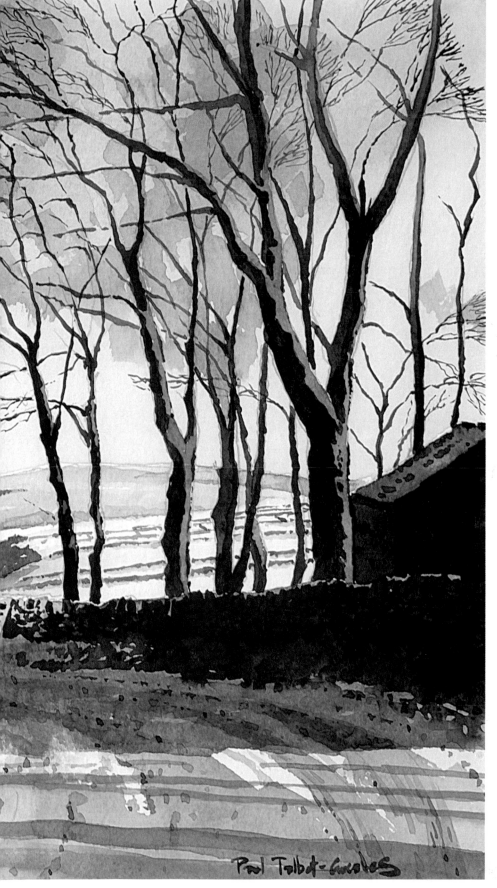

Paul Talbot-Greaves

Barn at Walshaw
22.9 x 33cm (9 x 13in)
This is a painting of contrasts – cool colours against warm colours, dark tones against light tones, and straight, architectural lines against the curvilinear forms of the trees. Although the subject has visual appeal, it was the contrasts in tone that initially inspired me to paint it.

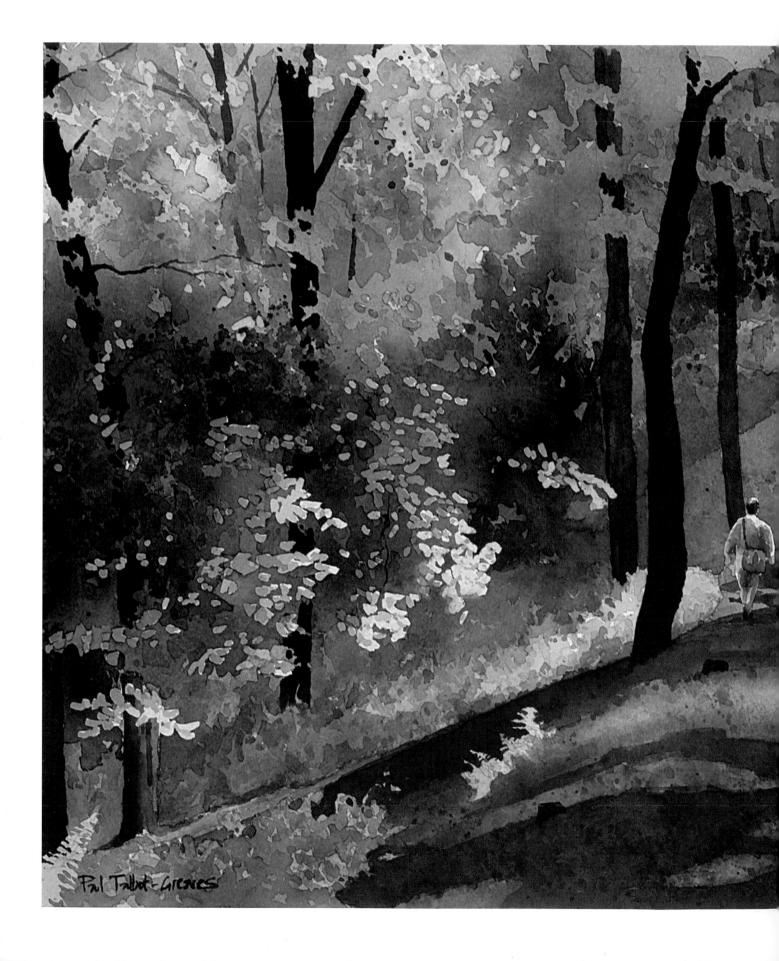

Paul Talbot-Greaves

A Woodland Walk in Summer

33 x 50.8cm (13 x 20in)

This painting was meticulously planned, with the lighter leaves masked out right from the outset. The main canopy of foliage was broadly washed in with varied greens and then built up with further layers of tone and colour, allowing drying stages between each layer.

templates

On these pages are the original scenes from which I drew the templates for my initial drawings in the bigger projects. Feel free to enlarge them and paint from them; also consider what I have left out and included in each one (see composition, page 28).

forest path project, page 68

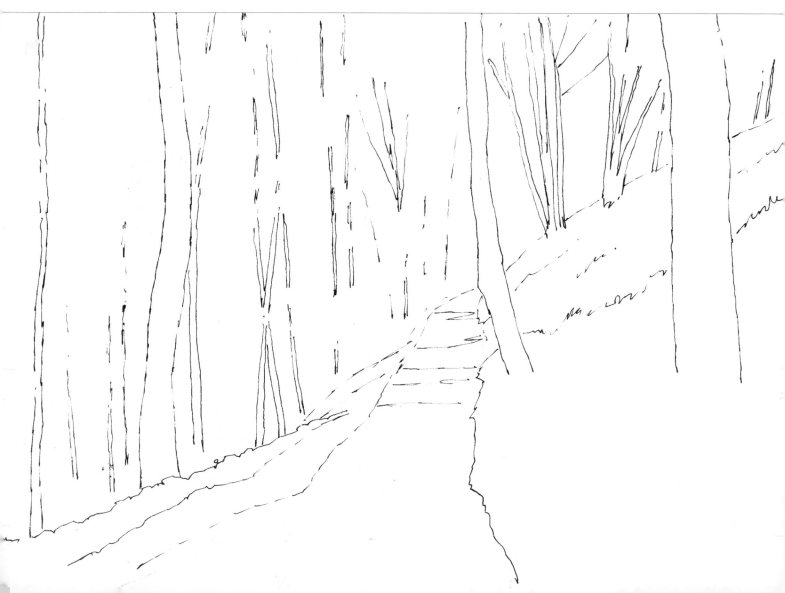

rural road project, page 74

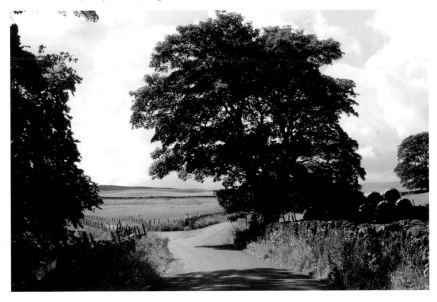

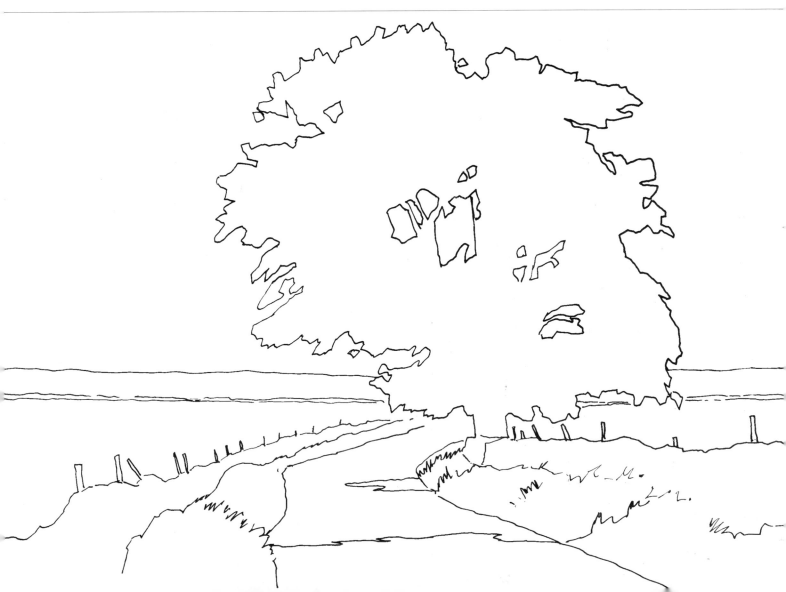

seasonal woods project, page 80

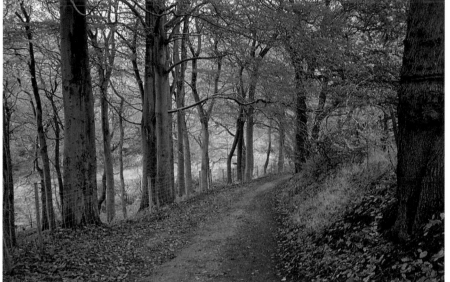

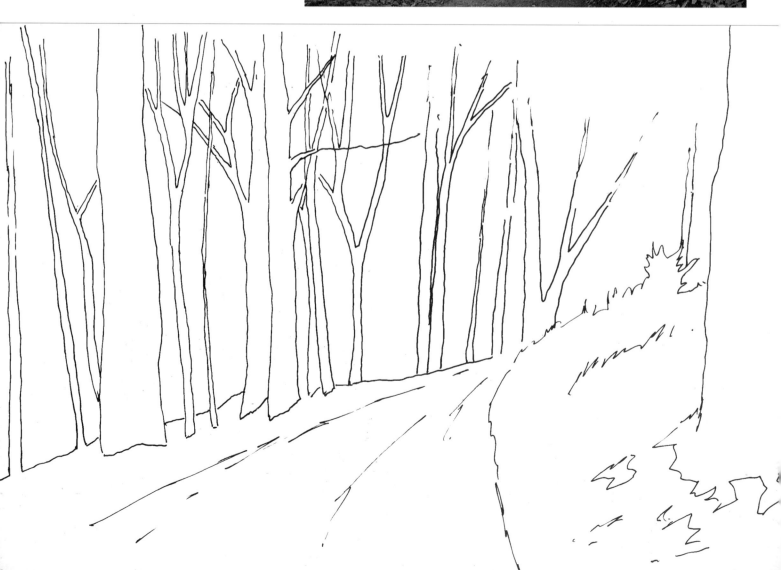

snow scene project, page 86

light and shade project, page 92

waterfall project, page 98

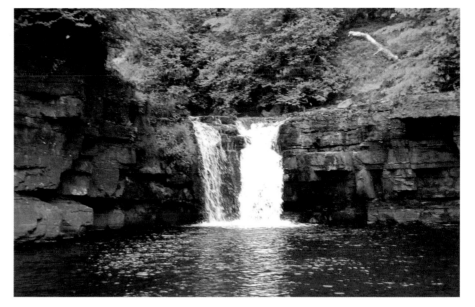

acknowledgements

I would like to express my gratitude and sincere thanks to all those who have worked so hard in creating this book, especially to Mic Cady, Lisa Wyman, Lewis Birchon, Ali Myer and everyone else involved at David & Charles, to Karl Adamson for his excellent photography and Ian Kearey for all his help, advice and reciprocal humour.

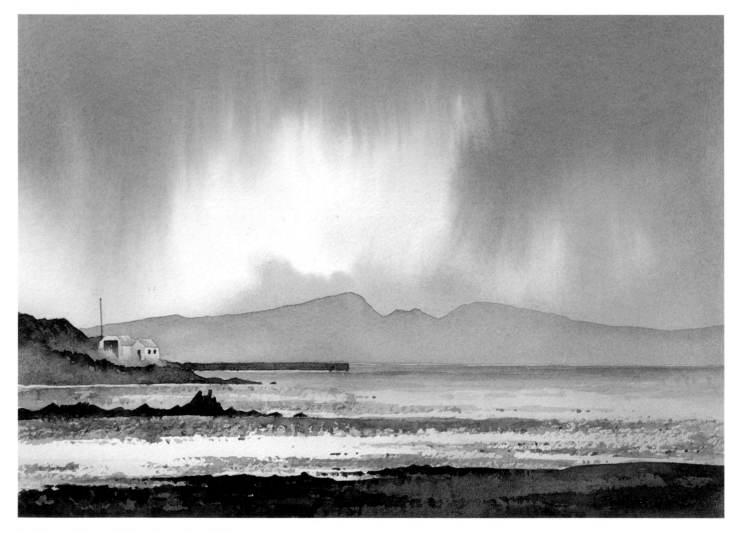

Loch Indaal, Islay, 22.9 x 33cm (9 x 13in)

Here, I have used the wet-into-wet technique to its full potential in order to invoke atmosphere into the scene. The painting was conducted on a rough-surface paper and this allowed me to use lots of drybrush technique to suggest the heavy textures in the bay. Note the strong focal point of the red door on the left-hand buildings.

index